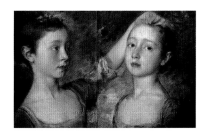

Lives of Gainsborough

T0149770

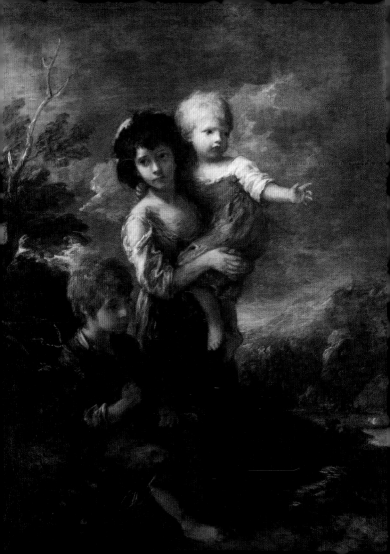

Lives of Gainsborough

Philip Thicknesse

William Jackson

Sir Joshua Reynolds

introduced by
Anthony Mould

J. Paul Getty Museum, Los Angeles

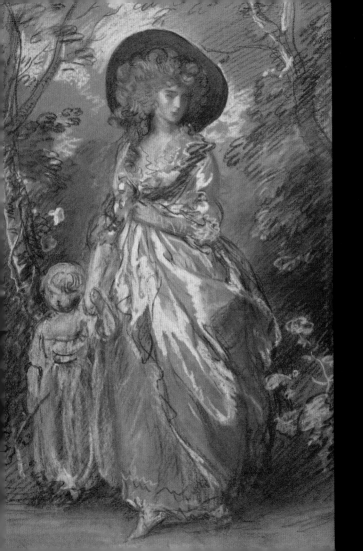

CONTENTS

Opposite: Woman walking in a garden with a child, c.1785

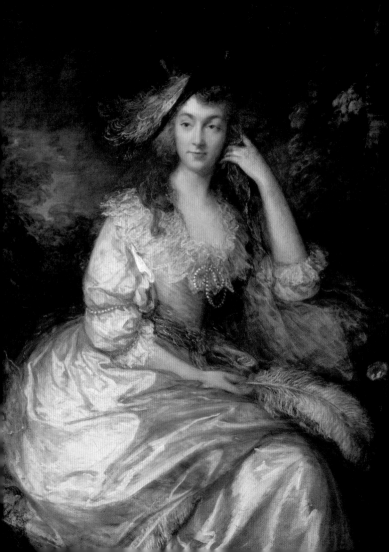

INTRODUCTION

ANTHONY MOULD

The sixty-one-year-old Thomas Gainsborough died with little fanfare in London in the summer of 1788. Journalistic response was muted, and unlike Sir Joshua Reynolds, whose funeral would witness several ducal pall-bearers, his own was by choice more modest. Within weeks however, the ever-opportunistic Philip Thicknesse (1719-1792) had produced his pop-eyed *Sketch of the Life and Paintings of Thomas Gainsborough*. Ten years later another, far more considered, personal memoir appeared, by the Exeter-based musician William Jackson (1730-1803). Both of these attested to Gainsborough's quicksilver charm and wit, and linked his art with his musicianship, an insight that still illuminates his work. Gainsborough's fellow artists also wrote about his technique and his achievement, none more carefully than his great rival Reynolds himself, who devoted his fourteenth *Discourse* in 1790 to Gainsborough. It was not then until after 1850 that appreciation picked up again, in tandem with a landmark exhibition of the *Blue Boy* (ill. p. 19) and

Opposite: Frances Susanna, Lady de Dunstanville, c. 1786

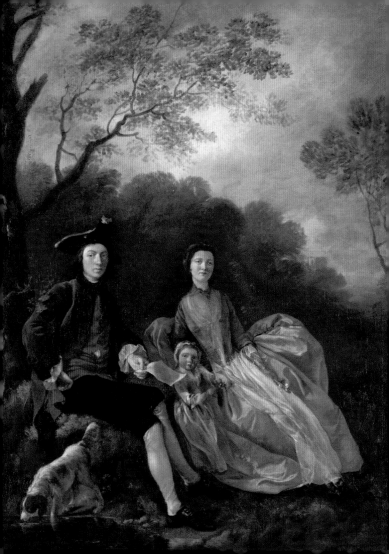

a stratospheric rise in prices. Consequently these early accounts have a particular value from being so close to events and giving us a direct impression of Gainsborough the man – and hence, very largely, of the painter too. It could be argued there are few painters whose temperament and outside interests are so evident in their art, far more than theory or ideology.

'Nature was his teacher,' declared his obituary in the *Morning Herald*, and he was a youthful prodigy, painting several notable landscapes (current whereabouts unfortunately unknown) between the ages of eight and ten in Sudbury, Suffolk, the town where he had been born in 1727. He may have been helped on his way by his mother, who was a competent flower painter, and must have provided early encouragement in both the graphic and plastic arts. (His father was a cloth merchant.) Supported by a wealthy paternal uncle, the young Gainsborough subsequently trained in a Hogarthian idiom at the newly formed St Martin's Lane Academy in London. In July 1746 he married Margaret Burr, the illegitimate daughter of the third duke of Beaufort, who had an annuity settlement of £200. This was a defining moment in his career: it enabled him to set up his own painting

Opposite: Self-portrait with his wife and daughter, c. 1748

Overleaf: Mr. and Mrs. Andrews, c. 1750

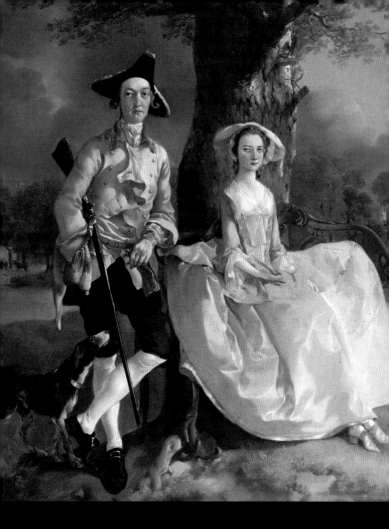

practice in Friar Street, Ipswich, in 1752. East Anglia was well-to-do, and picking up on the prosperity and confidence of the expanding empire. Art collecting, town and country house building, and middle class patronage of all varieties, were beginning to create opportunities for any aspiring portrait or landscape painter. Gainsborough was in the right time and place.

It was very shortly after his arrival in Ipswich that he must have first met – or been 'discovered' by – Philip Thicknesse. Thicknesse, one of the most cantankerous of English eccentrics, then had the prestigious post of governor of Landguard Fort in nearby Felixstowe. He did indeed commission, as he says, a large topographical view that was engraved by Thomas Major in 1753 and for which he had paid fifteen guineas (p. 41). But there were already connections with other patrons, such as the wealthy, perceptive and influential Price family of Foxley in Herefordshire. The Prices, close kin to the Beaufort family and surely aware of Gainsborough's skills by the time of his marriage in 1746, were also commissioning him in early Bath days and may indeed have had a sounder claim to such a 'discovery'.

Whatever the truth, Thicknesse was to develop an obsessive concern with having 'discovered' the young painter that almost extended to a fanatical sense of ownership of the whole family. He may have influenced

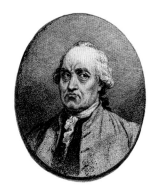

Philip Thicknesse,
engraving by
James Gillray, 1790

Gainsborough's move to Bath; he certainly kept up with the painter there, and his account gives a colourful, if surely not strictly accurate picture of Gainsborough's life in the city. They were both part of the city's musical circles, with Thicknesse latterly marrying Ann Ford, a performing musician whom Gainsborough painted in 1758 (p. 46). But Thicknesse was unfortunately something of a 'nearly' man, envious of the talents of others. With an eye to the main chance, his often accusatory comments ultimately speak more of his own misplaced vanities than of Gainsborough's implied lack of humility. Æsthetically, Thicknesse's remarks on the young Gainsborough's understanding of colour and his trumpeted expertise of the eager but limited young apprentice Dupont border on the jejune and betray a certain naïvety.

That he also brought about the Gainsborough family's next move, their permanent departure from Bath to London in 1774, may simply be another fanciful claim. Of the uncompleted portrait of Thicknesse that is the key to this narrative, nothing survives.

Thicknesse emphasizes Gainsborough's musical enthusiasms, which sometimes seem stronger than his vocation as a painter. The other early biographer, William Jackson, also straddled both worlds. An organist at Exeter Cathedral from 1777, Jackson was also a competent artist, working occasionally, if somewhat nervously, in Gainsborough's style. His essay, part of an Ovidian exercise called the *Four Ages*, attempts a more thoughtful analysis of Gainsborough the artist, which he takes up again in a subsequent chapter on the 'Character of Joshua Reynolds' whom he also knew well.

In the *Four Ages* Jackson sets up Gainsborough as the spontaneous empirical observer in contrast to Reynolds, the academically superior and somewhat pedagogic rationalist. Reynolds had already observed in the 1790 *Discourse* that his rival's ascent had come about without the assistance of 'an academical education' but Jackson's more complete seer/thinker contrast is surely overstated. If one turns to Gainsborough's letters – and Jackson himself observes 'For a letter to an intimate friend he had few equals, and no superior' and even compares them to

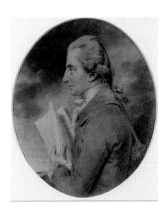

William Jackson, drawing by
John Downman, 1781

the electrifying epistolary style of Lawrence Sterne – one can see a near-forensic mind at play. Like the drawings, Gainsborough's letters were often executed at speed, but with subtle changes of tense and tone that suggest that if he had so wished, he could have been a public match for his more vocal and voluble arch-rival Sir Joshua.

Nor was Gainsborough in any way romantic or unworldly. It seems that he was a natural teacher, and he was certainly a successful businessman. His drive to carve out a well-defined commercial niche is seen in his systematic and uncanny knack of creating a portrait 'likeness' – as if a sitter were depicted from several angles simultaneously – which he had already developed in the early Ipswich

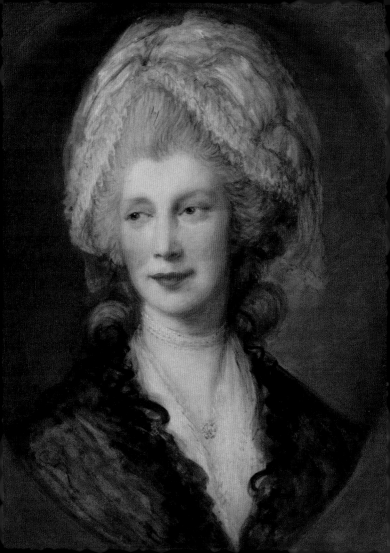

days, when he was setting himself up and had a burgeoning family to support. Martin Postle has described how Gainsborough combined a sharp and intuitive business sense with an ability to create and sustain an elevated circle of clients though a blend of charm and social flexibility. Prices for his paintings continued to rise with an increased demand, and if one client proved impatient, there was always another earl, squire, or prosperous landowner at the studio door. While excoriating some of his clients in private correspondence, his practice thus grew steadily in both scale and grandeur, and by 1783 he was the King's painter in all but name with a lively, easygoing, sometimes pedagogic relationship with the royal family. This represents the summit of his material achievements, but there was never an intellectual let-up.

Jackson's quip that at times painting was Gainsborough's pleasure and that music was his profession should not invite the conclusion that at any point he was an amateur painter-practitioner. All the indications of more recent research and Gainsborough's own letters support the view that his own understanding of 'genius' was something brought about by an earnest imitation rather than arrived at by unanticipated inspiration. Jackson relates elsewhere that on his deathbed Gainsborough

Opposite: Queen Charlotte, 1782

bemoaned the fact that after fifty years of practice 'I am only just beginning' and it was reported by Farington, that according to William Pearce who was there present, that he also stated that 'Vandyke *(sic)* was right'. What this remark precisely meant eludes us, but from the earliest stage copying and imitating others, the variegating and modulating of versions inspired by old master painters from Ruisdael to Murillo is testament to an attempt at universality in his pictorial psyche. This mirroring of Van Dyck, who was himself a veteran copyist, and which was achieved according to Reynolds, to 'perfection', is reflected in his own systematic repetitions of his own paintings, either for commercial purposes or as an exercise best understood as a kind of modulation and counterpoint, almost musical in form. How these variant repetitions and versions were ever exhibited is not yet clear, but there are numerous examples of citations of both landscapes and portraits, often for reasons as yet unexplained. They are never 'modulated' in exactly the same way on closest physical examination and what this can mean we do not yet know. Gainsborough, though restlessly active (he was undoubtedly the most prolific draughtsmen of his time) was also capable of intense observation: Jackson playfully observed that he got as

Opposite: The Blue Boy (probably Jonathan Buttall), c. 1770

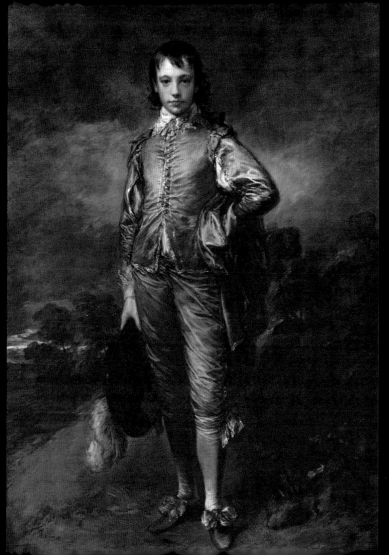

much pleasure from looking at a violin as from playing it, but another musician, Hamilton, noticed the trance-like state that apparently overcame him when gazing 'riveted' at a musical instrument for fully half an hour, overcome by the sheer beauty of its manufacture. For Gainsborough 'copying' and 'looking' were perhaps parallel disciplines.

Ultimately it is the refined classicism of the seasoned and wide-ranging copyist that is perhaps the key to the man. One might compare Johann Sebastian Bach, who frequently reused works from other composers, and never hesitated to reconfigure his own work. For both of them, one might say, the process was just one more continuing aid to a greater personal refinement. Gainsborough was in fact a close friend of Bach's youngest son and pupil, Johann Christian, music master to Queen Charlotte, and painted him twice (see p. 90). Through J. C. Bach he also knew the great viola da gamba player, Carl Friedrich Abel, another pupil of Johann Sebastian, and could even have met the young Mozart on his visit to London in 1764. Mozart later wrote variations on a minuet by Johann Christian Fischer, the oboist who married Gainsborough's daughter Mary in 1780. Gainsborough was a constituent part of a tight and exalted musical circle and even wrote music – now missing – himself.

Like Mozart, who appears to have performed and

reused works by both Bach and Abel while in London, Gainsborough was therefore not simply a 'natural' painter but on the contrary understood and explored his position within an existing tradition. Thus, although Jackson states that Gainsborough had 'no relish for historical painting', it must have been an irony for both him and for Reynolds, who had spent an entire career promoting the importance of history painting, that arguably Gainsborough's most successfully elegant oil composition of the 1780s was his 'historical' painting of *Diana and Actæon*, now in the Royal Collection in London, astutely acquired by the Prince Regent from the young Gainsborough Dupont in 1797 (ill. overleaf). A response to brief passages of natural description occurring within Ovid's *Metamorphoses*, this composition approaches a constructional perfection that breaks new technical ground. As a veteran painter, he was surely now aware of this, and it is no surprise that the painting remained with him in his studio. It is a work that defies strict categorization in a hierarchically demanding and institutionally conventional artistic environment. Larger than a Constable six-footer, it is a fusion of the informal imagery of Watteau and Fragonard and the more classicised formality of 'High Art'. An essay in 'studied carelessness' it is also a 'history' painting to compare with a late Titian, and an unconscious prefiguration of Cezanne's

d Actæon,
1785-88

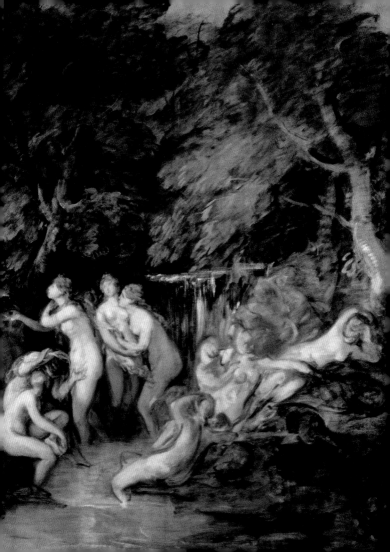

famous series of *Bathers*. Like his own fine *Musidora* in the Tate, which draws upon a characterization within the widely read Thomson's *Seasons*, it subtly acknowledges academic norms and conventional literary and classical sources, despite Jackson's assertions. It represents a new and thrilling way forward.

It is also the painting by which its creator should now be best judged. If for Gainsborough this is the moment that represented a 'beginning', it had already had its sub-liminal roots in his youthful *Cornard Wood* (National Gallery), where water is pictorially manipulated, or in his little nocturnal compositions from broccoli, coal, clay, moss and broken-looking glass that were almost sculptural in format, and in the originality of the mul-tiple designs of sheep and water that he could always draw, quite literally until the cows came home. Its light tone, fluidity of pigment, and control of composition that holds our attention today, 'unfinished' as it perhaps is, for perhaps it is not? According to one of Reynolds' paraphrased quotations of his rival in the *Discourses*, 'his regret at losing his life was the regret of leaving his art'. Did Gainsborough feel himself on the edge of something momentous here, a sense surely exaggerated by impend-ing mortality but nonetheless less probably true? *Diana and Actæon* asks the more modern question of how or

Opposite: Musidora, c. 1780-88

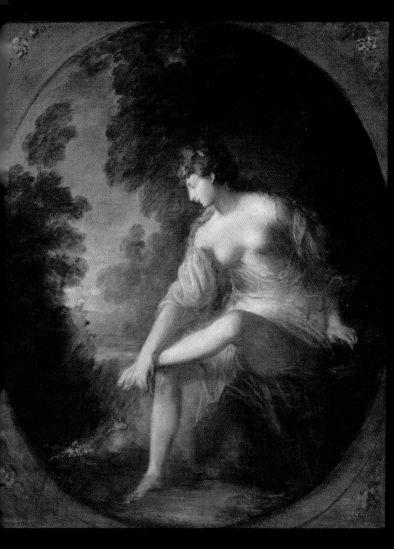

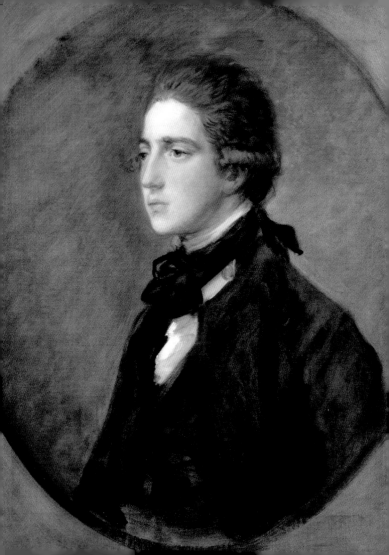

when any 'finished picture' really is exactly that. It was the Slade Professor Euan Uglow who pithily commented that no picture is ever 'finished' (nor, by implication, will it ever be).

In fact this quality is part of Gainsborough's entire character as a painter. Almost all commentators remark upon the speed of execution which facilitated his methods and was indeed integral to it, with the outcome being uninhibited by this rare combination of immediacy and of dexterity. One of the best known examples of this is perhaps the half-length oil on canvas portrait of the young musician Samuel Linley at the age of eighteen, now in the Dulwich College collection and executed, bewilderingly, in well under an hour in 1778. We might even wonder if it was perhaps Gainsborough's 'studied carelessness' that had ultimately infuriated Thicknesse, not just the cavalier failure to complete his full-length portrait once commenced. This was behavioural *sprezzatura*, Castiglione's word for the insouciance that marked out the gentleman-courtier. Jackson writes at one point about the airiness of both Gainsborough's letters and his conversation, compared it to that of a swallow. This observation ought not be allowed disguise Gainsborough's originality, his attempts at universality and lifelong quest for the mastery of perfect

Opposite: Samuel Linley, 1778

pitch. 'Damn him how various he is,' Gainsborough apparently once remarked enviously of Reynolds, when walking through the Royal Academy.

Thomas Gainsborough was manifestly a warm and affectionate character with a strong sense of his own worth and an ability to make friends quickly, but without always the time to sustain them as he might have wished. Ambition could get in the way. He was not quarrelsome, but friendships required servicing. Thicknesse, though himself capable of quarrelling with anyone, appears genuinely grieved by their estrangement. The friendship with Jackson cooled owing, it seems, to Gainsborough's drinking. With Reynolds there had never been a closeness, and nothing came of the 1782 agreement to paint each other's portraits in almost gladiatorial fashion. Yet when he was close to death Gainsborough asked Reynolds to come to see him, and the mutual declaration of respect is movingly if discreetly conveyed by Reynolds in the *Discourse*. 'Without entering into a detail of what passed at this last interview, the impression of it upon my mind was, that his regret at losing life was principally the regret of leaving his art'. Not just, however, his own: 'We are going to heaven,' Jackson famously reported him saying, as his last words, 'and Van Dyke will be of the company'.

PHILIP THICKNESSE

A Sketch of the Life and Paintings of Thomas Gainsborough

1788

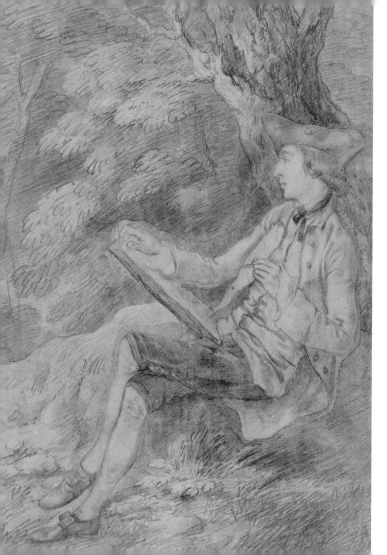

If an intimate acquaintance, and a most affectionate regard for upwards of thirty five years, with the lately departed, excellent, and first Artist as a Painter, Britain ever produced, could be deemed a qualification to write memoirs of his life and Paintings, so far, and no further, I am competent to the task I have undertaken; but to do Mr. Gainsborough justice, it requires a pen, equal to his own inimitable pencil, to hold forth the powers it possessed, or the tender feelings of his heart, a task I am by no means adequate to, but as I can with truth boast, that I was the first man who perceived, though through clouds of bad colouring, what an accurate eye he possessed and the truth of his drawings, and who dragged him from the obscurity of a Country Town, at a time that all his neighbours were as ignorant of his great talents, as he was himself, I may justly claim the pleasure, (or vanity it may be called) of holding forth his merits, since they have been seen, admired, and acknowledged by all lovers of the Arts, and envied even by the FIRST ARTISTS his Contemporaries; for tho' many may excel in fine outlines, good likenesses, decorated with chaste, elegant, and high finished borrowed drapery in portrait painting, I will venture to

Opposite: Self-portrait, sketching, figure c. 1755, landscape c. 1759

PHILIP THICKNESSE

affirm, that no man living in this Kingdom, nor do I
believe in any other, possessed a genius so great, or so
universal as Mr. Gainsborough, for whether on Por-
traits, Landscapes, modelling, or Mechanics, all his
doings were equally excellent. This ingenious man
was born in the year 1727 at Sudbury in Suffolk, his
Father, who was a Clothier, and a Dissenter in that
Town, had a very large family, and could only bestow
an education sufficient, to put them in a way of pro-
viding for themselves, and he had sense enough to
perceive it was all they wanted, for all his children
were wonderfully ingenious, I was about to say, all
equally ingenious. Mr. Gainsborough, like the best Po-
ets, was born a Painter, for he told me, that during his
Boyhood, though he had no Idea of becoming a Painter
then, yet there was not a Picturesque clump of Trees,
nor even a single Tree of beauty, no, nor hedgerow,
stone, or post, at the corner of the Lanes, for some
miles round about the place of his nativity, that he
had not so perfectly in his *mind's eye*, that had he known
he *could use* a pencil, he could perfectly delineat-
ed. I say had he *known he could use a pencil*, for he could,
and did use one the *first time* he took it up in such man-
ner, that the first effort he made with one, is of a
group of Trees now in my possession, and they are
such as would not be unworthy of a place at this day,

32

in one of his best landscapes. At the same time that he gave me this, his MAIDEN DRAWING, it was accompanied with a great many sketches of Trees, Rocks, Shepherds, Ploughmen, and pastoral scenes, drawn on slips of paper, or old dirty letters, which he called *his riding School*, and which have all been given, borrowed, or *taken away* from me, except his *first wonderful Sketch*, which would have been gone also, but that I had pasted in a M. S. bound book of music, composed and written by my affectionate and departed brother; and as it is a wonderful performance even for a professed Master of the art of drawing, it shall be left with the publisher of this book ten days, for the inspection of the curious, and the confirmation of the truth of what I have advanced. Thus finding the bent of his genius, he went very young to London, where, by the assistance of his father; the powers of his genius, his modest deportment, and the elegance of his person; he obtained what is called in general, *many friends*, and by attending a drawing Academy, greatly improved his natural talents; but being, as I said above, of a modest, shy, reserved disposition, which continued with him till his death, he had not formed any high Ideas of his own powers, but rather

Overleaf: Wooded landscape with figures, cows and distant sheep, 1746-48

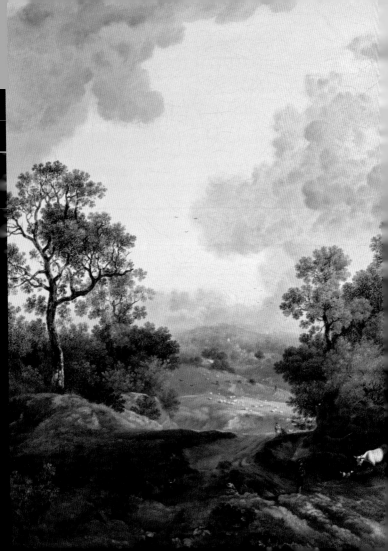

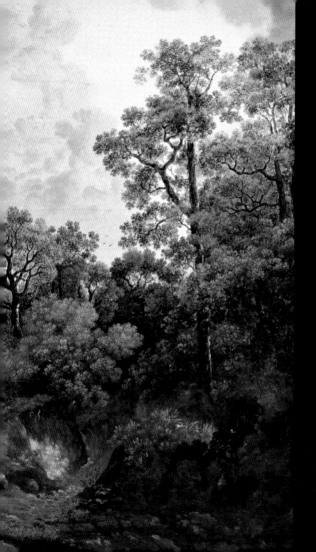

considered himself as one, among a crowd of young Artists, who might be able in a country town (by turning his hand to every kind of painting) [to] pick up a decent livelihood. When he obtained his nineteenth year, he met with a very pretty Scots girl, of low birth who by the luck of the day,* had an annuity settled upon her for life of two hundred pounds a year, to this girl he offered his hand and his heart, which perhaps no other woman of any fortune would at that time have refused, & then with his pretty wife, he retired to Ipswich in Suffolk, took a small house of six pounds a year in that Town, and considered himself happily settled for life. Soon after his remove to Ipswich I was appointed Lieutenant Governor of Land Guard Fort, not far distant, and while I was walking with the *then* printer and editor of the Ipswich journal, in a very pretty town garden of his, I perceived a melancholy faced countryman, with his arms locked together, leaning over the garden wall, I pointed him out to the printer, who was a very ingenious man, and he with great gravity of face, said the man had been there all day, that he pitied him, believing he was either mad, or miserable. I then stepped forward with an intention to speak to the *mad man*, and did not perceive, till I was

* No reflection is meant here on Mrs. Gainsborough's virtue.

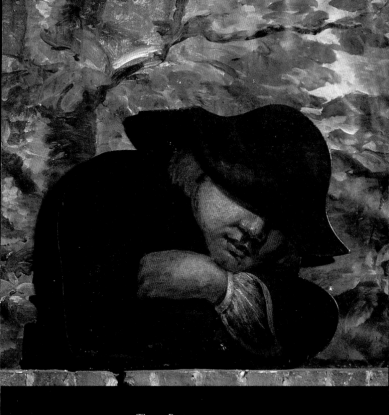

Thomas Peartree, c. 1750-59,
as currently displayed at Ipswich Museum

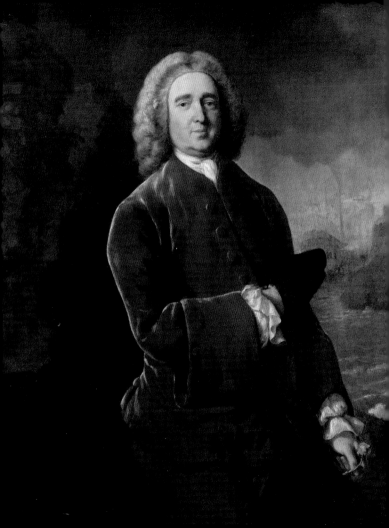

close up, that it was a *wooden man* painted upon a shaped board.[1] Mr. Creighton (I think that was the printer's name) told me I had not been the only person this inimitable deception had imposed upon, for that many of his acquaintance had been led even to speak to it, before they perceived it to be a piece of art, and upon finding the artist himself lived in that town, I immediately procured his address, visited Mr. Gainsborough, and told him I came to chide him for having imposed a shadow instead of a substance upon me. Mr. Gainsborough received me in his painting room, in which stood several portraits truly drawn, perfectly like, but stiffly painted, and worse coloured; among which was the late Admiral Vernon's,[2] for it was not many years after he had taken Porto Bello, with six ships *only*, but when I turned my eyes to his little landscapes, and drawings, I was charmed, those were the works of fancy and gave him infinite delight; MADAM NATURE, not MAN, was then his only study, and he seemed intimately acquainted with that BEAUTIFUL OLD LADY. Soon after this, the late King passed by the garrisons under my command, and as I wanted a

1. *c.* 1740, Ipswich Museum 2. *c.* 1753, Beningborough Hall

Opposite: Admiral Edward Vernon, c. 1753

subject to employ Mr. Gainsborough's pencil in the landscape way, I desired him to come and eat a dinner with me, and to take down in his pocket book, the particulars of the Fort, the adjacent hills, and the distant view of Harwich, in order to form a landscape of the Yachts passing the garrison under the salute of the guns, of the size of a panel over my chimney piece, he accordingly came, and in a short time after, brought the picture. I was much pleased with the performance, and asking him the price? he modestly said, he hoped I would not think fifteen guineas too much, I assured him that in my opinion it would (if offered to be sold in London) produce double that sum, and accordingly paid him, thanked him, and lent him an excellent fiddle; for I found that he had as much taste for music, as he had for painting, though he had then, never touched a musical instrument, for at that time he seemed to envy even my poor talents as a fiddler, but before I got my fiddle home again, he had made such a proficiency in music, that I would as soon have painted *against him*, as to have attempted to fiddle *against him*. I believe however it was what I had said about the landscape, and *Thomas Peartree's head*, which first induced Mr. Gainsborough to suspect (for he only suspected it) that he had something more in him, which might be fetched out, he found he could fetch a

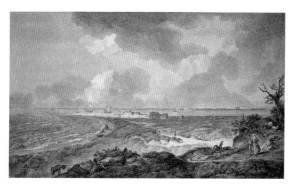

Thomas Major after Gainsborough, Landguard Fort, 1754

good tone out of my fiddle, and why not out of his
own *Palette?* The following winter, I went to London,
and I suspected, for like Mr. Gainsborough, I only sus-
pected, that my landscape had uncommon merit, I
therefore took it with me, and as Mr. Major the En-
graver, was then just returned from Paris, and es-
teemed the first artist in London in his way, I showed
it to him; he admired it so much, that I urged him for
both their sakes as well as mine, to engrave a plate
from it, which he seemed very willing to undertake,
but doubted whether it would by its sale (as it was only
a perspective view of the Fort) answer the expense; to
obviate which, I offered to take ten guineas' worth of

impressions myself; he then instantly agreed to do it. The impression will show the merit of both artists, but alas! the picture, being left against a wall which had been made with salt water mortar, is perished and gone. That engraving made Mr. Gainsborough's name known beyond the circle of his country residence, and he was soon after by me, and several of his friends, urged to remove to Bath, and try his talents at portrait painting, in that fluctuating city, at which time I had a house there and resided during the winters. After his arrival at Bath, I accompanied him in search of lodgings, where a good painting room as to light, a proper access, &c, could be had, and upon our return to my house, where his wife was impatiently waiting the event, he told her he had seen lodgings of fifty pounds a year, in the churchyard, which he thought would answer his purpose. The poor woman, highly alarmed, fearing it must all come out of her annuity, exclaimed 'Fifty pounds a year Mr. Gainsborough! why are you going to throw yourself into a gaol?' but upon my telling her, if he did not approve of the lodgings at fifty pounds a year, he should take a house of an hundred and fifty, and that I would pay the rent if he could not, *Margaret's* alarms were moderated.

As at that time I was better known, and better

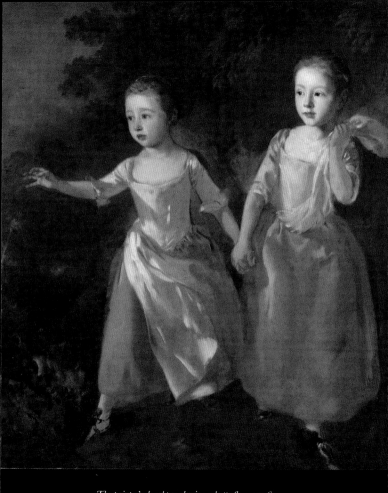

The painter's daughters chasing a butterfly, c. 1756

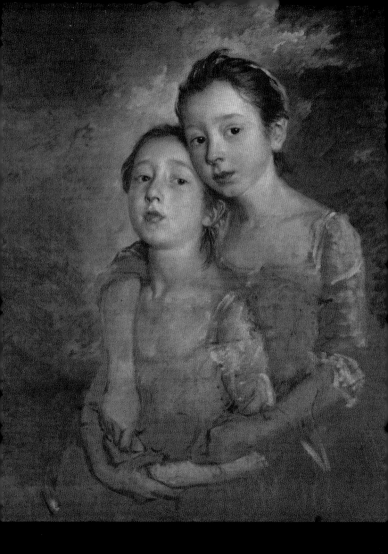

loved at Bath, than I am at this, *though I am a very innocent* and *unoffending man, except to Rogues and Rascals.* My head was to be held up as the decoy duck, but the first sitting (not above fifteen minutes) is all that has ever been done to it, and in that state it hangs up in my house at this day;[1] business came in so fast, at five guineas *a head*, that though he did not much mend in his colouring, or style, yet he was obliged to raise his price from five to eight guineas, and therefore I would not take up his time to finish mine, and perhaps too the finishing would not have mended it, the likeness, he could not: It is scarce necessary to say how rapidly, nor how justly, he raised his price from eight guineas, till he fixed it at forty for a half length, and an hundred for a full one; but before I proceed further, I cannot help relating a very singular and extraordinary circumstance, which arose between him, Mrs. Thicknesse, and myself; for though it is very painful for me to reflect on, and much more so to relate, it turned out fortunately for him, and thereby lessened my concern, as he certainly had never gone from Bath to London, had not this untoward circumstance arose between us; and it is no less singular, that I, who had

1. Lost

Opposite: The painter's daughters holding a cat, c. 1760-61

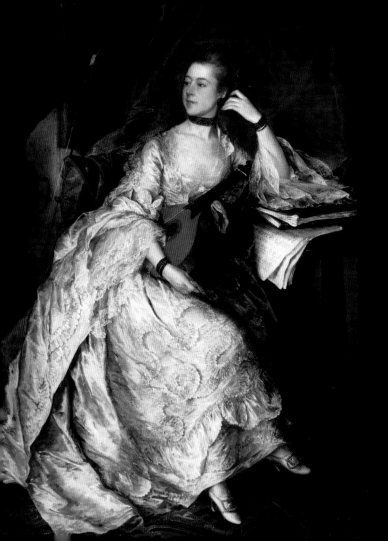

taken so much pains to remove him from Ipswich to Bath, should be the cause, twenty years afterwards, in driving him from thence! I believe I may venture to say, that all great geniuses are a little allied to a kind of innocent madness, and there certainly was only a very thin membrane which kept this wonderful man within the pale of reason. He had asked me when he first went to Bath, to give him the portrait of a little Spanish girl painted upon copper, with a guitar in her hand, and one feather in her hair, a picture now at his house in Pall-Mall, the study of which, he has often told me, made him a Portrait painter, and as he after-wards painted Mrs. Thicknesse's full length,[1] before she was my wife, he rolled it up in a landscape of the same size, and of his own pencil, and he sent it me to London by the waggon. I was much surprised at the first opening of it! to see the head of a large oak tree, instead of Mrs. Thicknesse's head, but I soon found between the two pictures, a note as follows. "Lest Mrs. Thicknesse's picture should have been damaged in the carriage to town, this landscape is put as a case to protect it, and I now return you many thanks for having procured me the favour of her sitting to me

1. 1760, Cincinnati Art Museum

Opposite: Ann Ford (later Mrs. Philip Thicknesse), 1760

for it, it has done me service, and I know it will give you pleasure."

During our residence at Bath, he had often desired me to sit to him for a companion to it, which I as often declined; not because I should not have felt myself and my person too, highly flattered, but because I owed Mr. Gainsborough so much regard, esteem, and friendship, that I could not bear he should toil for nothing, knowing how hard he worked for profit. However, during the last year of his residence at Bath, he *fell in love* with Mrs. Thicknesse's VIOL DI GAMBA, and often, when he dropped in to my house and took it up, offered me an hundred guineas for it; at that time I had reason to believe I might *not find it inconvenient*, ever to remove from my own house in the Crescent, and observing to Mrs. Thicknesse how much he admired her Viol, that he had some very good ones of his own, and that she might at any time have the use of either, she consented to give him an instrument made in the year 1612, of exquisite workmanship, and mellifluous tone and which was certainly worth an hundred guineas.* We then asked him and his family to supper with us, after which Mrs. Thicknesse

* After the death of my daughter, it was sold to Mr. Brodrep for forty guineas.

putting the instrument before him, desired he would play one of his best lessons upon it; this I say *was after supper*, for till poor Gainsborough had got a little borrowed courage (such was his natural modesty) that he could neither play *nor Sing!* He then played, and charmingly too, one of his dear friend *Abel's* lessons, and Mrs. Thicknesse told him he deserved the instrument for his reward, and desired his acceptance of it, but said at your leisure, give me my husband's picture to hang by the side of my own. An hundred full-length pictures bespoke, could not have given my grateful and generous friend half the pleasure, a pleasure in which I participated highly, because I knew with what delight he would *fag* through the day's work; to rest his cunning fingers at night over Abel's composition, and an instrument he so highly valued. Gainsborough was so transported with this present, that he said "keep me hungry! – keep me hungry! And do not send the instrument till I have finished the picture." The viol di gamba however was sent the next morning, and the same day he stretched a canvas, called upon me to attend, and he soon finished the head, rubbed in the dead colouring, of the full length, painted my Newfoundland dog at my feet; and then it was put by, and no more said of it, or done to it. After some considerable time he had passed Mrs. Thicknesse, and I called

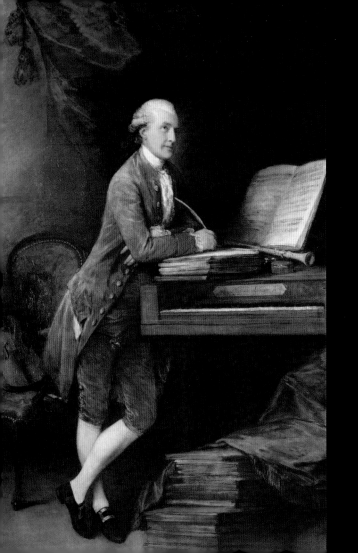

one morning at his house, Mr. Gainsbrough invited her up into his picture room, saying 'Madam, I have something above to show you.' Now the reader will naturally conclude, as she did, that it was some further progress upon my picture, which as it was last left, had something of the appearance (for want of light and shade in the drapery) of a drowned man ready to burst, or rather of a ragged body which had been blown about upon a gibbet on Hounslow Heath, for the dog's head, and his master's, were the only parts that betrayed the pencil of so great a master. But upon Mrs. Thicknesse's entering the room she found it was to show her, Mr. Fischer's portrait,[1] painted at full length, completely finished, in scarlet and gold, like a Colonel of the foot guard,and mine standing in its *tatter a ragg* condition by the side of it! Mrs. Thicknesse knew this was a picture *not to be paid for*, and that it was begun and completed *after mine*. She would have rejoiced, to have seen an hundred pictures finished before mine, that were to be paid for, but she instantly burst into tears, retired, and wrote Mr. Gainsborough a note, desiring him to put my pictures in his garret, and not let it stand to be a foil to Mr. Fischer's; he

1. 1774, Royal Collection

Opposite: Johann Christian Fischer, 1780

did so, and as instantly sent home the viol di gamba!
Upon my meeting Mr. Gainsborough, I believe the
next day, I asked him how he could have acted so very
imprudently? and observed to him that it was not
consistent with his usual delicacy, nor good sense, that
even if he had made a foolish bargain with her, yet
it was a bargain, and ought to be fulfilled, for I must
own, that had he been a man I loved less, I too should
have been a little offended. Now reason and good
sense had returned to my friend, 'I own,' said he, 'I
was very wrong, not only in doing as I did, but I have
been guilty also of shameful indelicacy in accepting
the instrument which Mrs. Thicknesse's fingers from
a child had been accustomed to, but my admiration
of it, shut out my judgement, and I had long since
determined to send it her back with the picture and so
I told Mr. Palmer' (and so he did) adding, 'pray make
my peace with Mrs. Thicknesse, and tell her I will fin-
ish your picture in my very best manner, and send it
her home forthwith'. In a few days after, we three met,
and they two shook hands and seemed as good friends
as ever; but, days, weeks, and months passed and no
picture appearing, either at his house or mine, I began
to think it then became my turn to be a little angry
too; for I suspected, and I suspected right, that he had
determined never to touch it more! and I wrote him

a letter and told him so, adding that Mrs. Thicknesse was certainly entitled to the picture, either from his JUSTICE or his GENEROSITY! that I would not give a farthing for it, as a mark of his justice, but if he would send it to me from his generosity unfinished as it was, I should fell myself obliged to him; *and he sent it as it was!* [1] Nothing but knowing the goodness of his heart, the generosity of this temper, and the particularities of *his mind*, could ever have made me, even speak to him again, after having given me so deadly a blow, for it was a DEADLY ONE; but I knew, though it seemed *his act*, it did not originate *with him*; he had been told that I had said openly in the public coffee-house at Bath, that when I first knew him at Ipswich, his children were running about the streets there without shoes or stockings; but the Rascal who told him so, was the Villain who robbed the poor from the plate he held at the church door for alms! That Mr. Gainsborough did not believe me capable of telling so gross a falsehood, I have his authority to pronounce, for he told me what he said in return. 'I acknowledge' said he, 'I owe many obligations to Mr. Thicknesse, and I know not any man from whom I could receive acts of friendship with more pleasure,' and then made this

1. Lost

just remark. 'I suppose,' said he, 'the Doctor knew I now and then made you a present of a drawing, and he meanly thought, by setting us at variance, he might come in for one himself.'

The first time I met Mr. Gainsborough after he had presented me with my own unfinished picture, I saw that concern and shame in his face, which good sense, an upright heart, and conscious errors, always discover. I did not lament the loss of his finishing strokes to *my Portrait*, but I grieved that it had ever been begun; he desired I would not let any other painter touch it, and I solemnly assured him, it should never be touched, it had I said been *touched* enough, and so had I, and then the subject was dropped; but every time I went into the room where that scarecrow hung, it gave me so painful a sensation, that I protest it often turned me sick, and in one of those sick fits, I desired Mrs. Thicknesse would return the picture to Mr. Gainsborough, and that as she had set her heart upon having my full-length portrait, I would rather give Mr. Pine his fifty guineas for painting it, than be so daily reminded and sickened at the sight of such a glaring mark of disregard from a man I so much admired, and so affectionately esteemed. This she consented to do, provided I would permit her to send with it a card, expressing her sentiments at the time,

to which I am sorry to say, I too hastily consented. In that card she bid him take his brush, and first rub out the countenance of the truest and warmest friend he ever had, and so done, then blot him forever from his memory. Upon the receipt of that note, he went directly to London, took a house in Pall-Mall at three hundred pounds a year rent, returned to Bath to pack up his goods and pictures, and sent me a note upon a slip of paper wherein he said: "God bless you and yours, I am going to London in three days."

Well knowing my Man, and having had so recent a proof his being *sometimes* capable of acting very injudiciously, I was much alarmed, lest with all his merit and genius, he might be in London a long time, before he was properly known to that class of people, who alone could *essentially* serve him, for of all the men I ever knew, he possessed least of that wordly knowledge, to enable him to make his own way into the notice of the GREAT WORLD. I therefore wrote to Lord Bateman who knew him, and who admired his talents, stating the above particulars, and urging him at the same time for both our sakes, to give him countenance and make him known, that being all which was necessary. His Lordship for me, or both our sakes did so, and his remove from Bath to London proved as good a move, as it was from Ipswich to Bath. It was not one, or two,

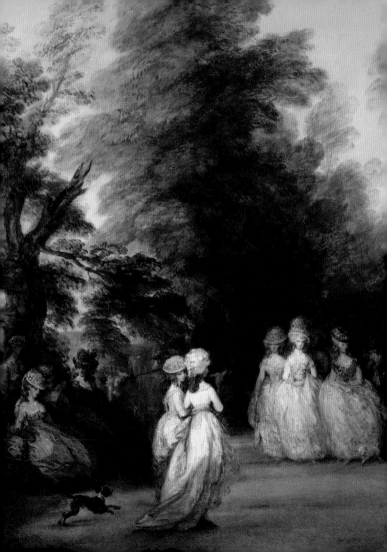

*The Mall in
St James Park,
c. 1783*

ill-judged actions, among a thousand great, good, and generous ones I knew him to be *guilty of*, which could break off our friendship, nor did he *background-brush* my countenance as Mrs. Thicknesse had desired, for some years afterwards I asked him whether he had so done! 'no, no,' said he, *colouring* (for he was a great colourist) 'one day or other, some of your family or friends will be glad of it', *but I now suspect it had had the brush, or the scissors, a fate many of his Portraits has met with, in the course of forty years. – Jealousy, or hatred, has occasioned many such murderous deeds!!* but those who best loved Mr. Gainsborough, and whom he most loved, were unfortunately least welcome to his house, his table, or the goodwill of some part of his family; for he seldom had his own way, but when he was roused to exert a painful authority for it, and then he flew into irregularities, and sometimes into excess, for when he was once heated, either by passion, or wine, he continued unable and unwilling also, to do business at home, and at those times squandered away fifty times over, the money which an extra joint of meat, or a few bottles of port would have cost, to have entertained his friends *at home*. I mention this, because had it not been for,

Opposite: Henry, Duke of Cumberland, with Anne, Duchess of Cumberland, and Lady Elizabeth Luttrell c. 1785-88

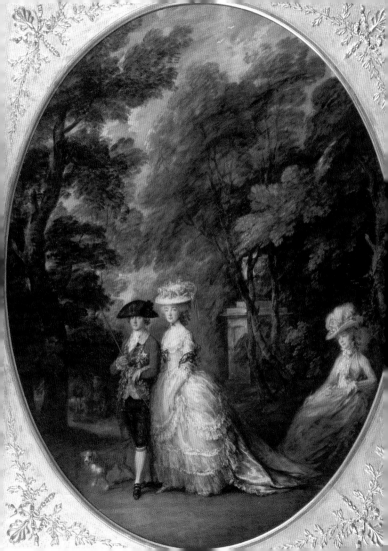

such pitiful doings, he would have been still in all human probability, the delight of his friends, and the admiration of all the world, for years to come. *He* had so utter a disregard to money, that *somebody* smuggled up in a few years at Bath, five hundred pounds. Those who have sat to Mr. Gainsborough know, that he stood, not *sat* at his Palette, and consequently, of late years at least, five or six hours work every morning, tired him exceedingly, and then, when he went into the park for a little fresh air, or up into the city upon business, if he took a hackney coach to ease his tired limbs back again, he was obliged to be set down in St. James's Square, or out of the sight of his own windows, for fear of *another set down* not so convenient either to his *head*, or his *heels*, as riding out twelve penny-worth of coach hire, after having earned fifty guineas previously thereto! I have more than once been set down by him in that manner, even when I was going to dine with him, and have more than once been told by him why we were so set down! If therefore I have told this tale too severely, let it be remembered, that I have lost a friend whom I sincerely loved; the public have lost a most valuable and Eminent artist, his numerous relations, (some of whom he

Opposite: Margaret Gainsborough, the painter's wife, c. 1778

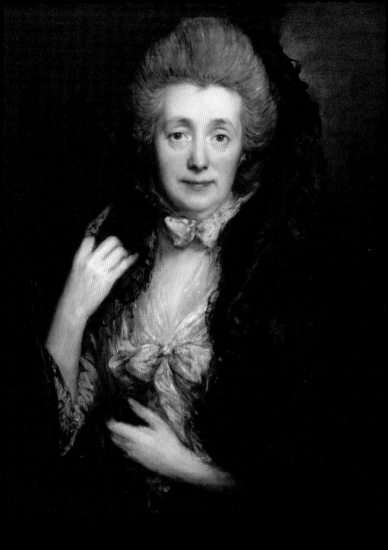

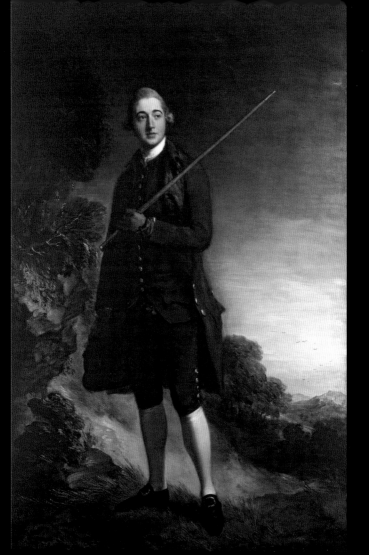

generously maintained, and all of whom he affection-
ately loved) have lost their support; and therefore "*let
the stricken deer go weep*" while the Portraits of Lord Kill-
morrey,[1] Mr. Quin,[2] Mr. Medlicote,[3] Mr. Mosey,[4] Doc-
tor Charlton,[5] Mr. Fischer[6] and Mrs. Thicknesse exist;
his talents as a Portrait painter must be admired for
their strong likeness, elegance of attitude, and the PER-
MANENCY of their colouring.* These and many more
were finished *before* he left Bath, and that of his MAJ-
ESTY GEORGE THE THIRD,[7] the QUEEN,[8] the three Royal
Sisters upon one canvas.[9] The Prince of WALES,[10]
Colonel St Ledger,[11] Mr Bates,[12] and many others,
painted *after* he was settled in London, will forever

* Mrs. Thicknesse's picture was painted in the year 1761, and the
colours though it has been carried all over Europe, are as vivid as the
first day it was painted, I mention this as a hint to *the Knight*.

1. 1768, London, Tate 2. 1763, Dublin, National Gallery of Ire-
land; sketch in Royal Collection 3. *c*.1773, private collection
4. *Abel Moysey*, 1771, private collection on loan to Gainsborough's
House, Sudbury 5. *c*.1764, Bath, Holburne Museum 6. 1780
Royal Collection 7. & 8. Unidentifiable with certainty 9. *Three
Eldest Daughters of George III: Princesses Charlotte, Augusta and Elizabeth*,
1784, Royal Collection. Now cut down but complete composition
known through copies 10. 1781, Waddesdon Manor 11. 1782, Royal
Collection 12. Probably Sir Henry Bate Dudley, 1780, private collec-
tion on loan to Tate, London

Opposite: Abel Moysey, 1771

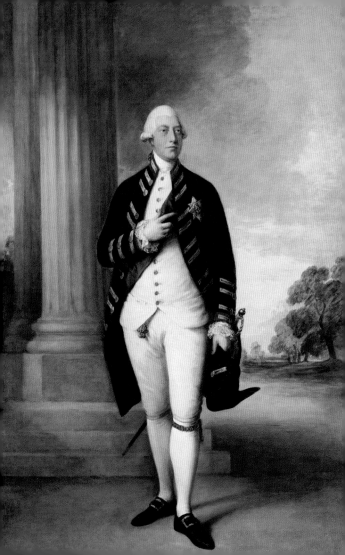

Immortalize him as a perfect master of that art. The KING's Portrait and Mr. Bates, are perhaps the two most perfect Portraits of both face, and persons, that ever were delineated upon canvas, but great as those Portraits in particular are, and excellent as most of his pictures in that way are finished, it was necessity, not choice, which drew him from his favorite study, the study of NATURE, and in those representations, let his pictures from nature *speak*, as they will, while canvas and oil can endure, and call forth the admiration of all beholders, and the imitation of all inferior artists. It would be impertinent to say more of his talents as a landscape painter, while there are so many *witnesses* in the world under his own *hand* of the intimacy and friendship there was between him and dame Nature, for I may justly say;—NATURE sat to *Mr. Gainsborough* in all her attractive attitudes of beauty, and his pencil traced with peculiar and matchless felicity, her finest and most delicate lineaments; whether from the sturdy oak, the twisted eglantine, the mower whetting his scythe, the whistling plough boy, or the shepherd under the hawthorn in the dale; all came forth equally chaste from his inimitable and fantastic pencil. But

Opposite: George III, 1780-81

Overleaf: Mountain landscape with bridge, c. 1783-84

PHILIP THICKNESSE

perhaps even the greatest part of this master's genius is still unknown but to a few! After returning from the Concert at Bath, near twenty years ago, where we had been charmed by Miss Linley's voice, I went home to supper with my friend, who sent his servant for a bit of clay from the small beer barrel, with which he first modelled, and then coloured her head, and that too in a quarter of an hour, in such a manner that I protest it appeared to me even superior to his paintings! the next day I took a friend or two to his house to see it, but it was *not* to be seen, *the servant had thrown it down from the mantelpiece and broke it;* but as I said above, all great genius is a little allied to something which commonplace understandings cannot comprehend! for I am well convinced that if I had asked him for five hundred pounds to save me from a gaol, I should not have gone to a gaol, but I am as thoroughly convinced, that no earthly consideration could have prevailed upon him (after what had passed) to have touched my picture again; but as enough has been said as to the merits of his pencil, I have only to add a few specimens of the benevolence of his heart. A gentleman and a friend of mine, had without letting me know his distress, shot himself in this city, I found by some

Opposite: Elizabeth Linley (Mrs. Richard Brinsley Sheridan), 1785-87

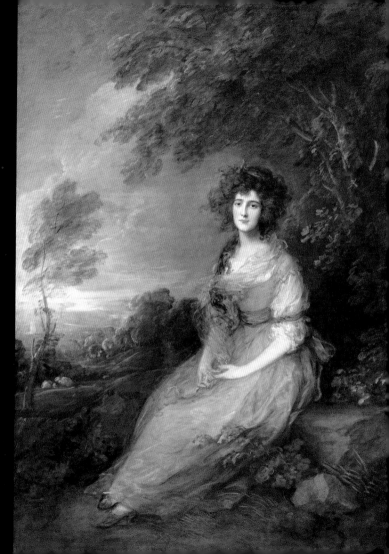

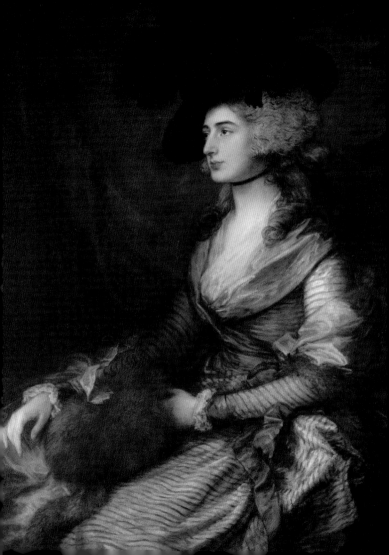

letters from a female which came into my hands from the CORONER that he was connected with a woman in London who had painted the distress of her mind, in those letters *à la Gainsborough*, I wrote to her, and her reply to me was of the same cast, and meeting Mr. Gainsborough going to the play when I had her letter in my hand, I showed it to him; I saw the stifled tear ready to burst from his eyes and so quitted him, but instead of going to the play, he returned home, sent me a bank note in a letter, wherein he said, "I could not go to the play till I had relieved my mind by sending you the enclosed bank note, which I beg you to transmit to the poor woman by tomorrow's post." His susceptible mind and his benevolent heart, led him into such repeated acts of generosity, that at *that* time, I know he was not rich, and I suppose he did not die, worth a tenth part of what he might have been possessed of, had he been a worldly minded man; a Humourist he certainly was, but in the most pleasant cast of that character, for when a certain rich citizen was sitting to him with his five guinea new powdered bob wig on, the *chap* looked so *rum*, and sat so very *pretty*, that poor Gainsborough found it impossible not to burst out in a fit of laughter, and while he was wishing

Opposite: The actress Mrs. Siddons, 1785

71

for some occasion to plead his excuse, the Alderman desired him not to overlook the *dimple in his chin*; no power of face could stand that; —Gainsborough burst forth in laughter, threw his pencil upon the ground, and said 'd—n the dimple in your chin, I can neither paint that nor your chin neither,' and never touched the picture more; and when a certain Duchess sent to know *the reason why her picture was not sent home?* he gave it a *wipe* in the face with his *background-brush*, and sent her word that her Grace was *too hard* for him, he could not he said paint it. That inelegant message, lost her an excellent representation of her beautiful person (for she *was* beautiful) and Gainsborough's spirit, deprived him of an hundred guineas. Vanity, or affectation, I care not which way it is construed, will not let me withhold a little domestic occurrence. My departed daughter, who had some claim to genius with her pencil, and now and then obtained a hint of importance from Mr. Gainsborough's, had prevailed upon him to give her a little faint tinted drawing of his to copy, from which, she made so exact a resemblance, that at a slight view, it was not readily distinguished from the original; one night, *but after supper*, at my house in town, she laid her copy before him, said nothing but waited to hear what he would say, Gainsborough instead saying anything, took it up and

instantly tore it through the middle! The truth was, inattention, good spirits, and a glass or two of wine, had so cheered him, that he thought it was his own, yet at the same time perceiving that it was not quite so perfect as a work of *his* ought to be, he demolished it. It is scarce necessary to say, that he made her a *second* amends, for this compliment, by presenting her with another drawing which will never be torn, and *now* I consider that which was torn, as valuable as either. Having said thus much of my departed friend, I cannot lay down my pen without mentioning Mr. Dupont his surviving nephew and scholar, who has been fostered under his wing from a child, to his dying day, because I can venture to pronounce him a man of exquisite genius, little inferior in the line of a painter to his uncle, possessing an excellent heart, and a good understanding; and when his works are known, they cannot fail of being equally admired, and I hope and believe, if his own diffidence and modesty does not prevent him, that he will not remove from his late uncle's house, for I am sure he can support its former credit, either as a landscape or Portrait painter. If anyone doubt it, I refer them to a portrait of his uncle, which I have not seen of many years, but which has all the ease, all the spirit, and all the fire in it, which might be expected in the Portrait of the first genius, as I have

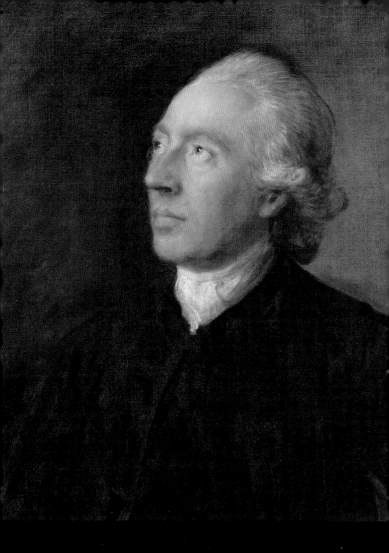

said above, either this, or in any other Kingdom ever produced. Mr. Gainsborough's father left eight children, Thomas was the youngest, three sons and five daughters, his sons were all wonderfully ingenious, his daughters handsome and virtuous. The Rev. Mr. Gainsborough who died a few years since at Henley, was as much beloved as lamented, for he was not less ingenious as a mechanic, than his younger brother was in painting. After his death, my friend his brother gave me all his finished and unfinished works, among which is a clock now in my own house (not given by me as by mistake was mentioned in the gazetteer to the British Museum) of too curious a construction for me to attempt to describe, a sundial, a piece of work of great delicacy and of infinite labour, I did present to the British Museum, but nothing could have induced me to part with it, but that it might be placed, as I told the Governors in a letter which accompanied it, where it would remain, a specimen of his genius, as long as brass or iron can endure, it was, as the clock is, all the work of his own hands, and I soon after received a letter from the Governors, thanking me for having enriched the British Museum with so great a curiosity, and there it may be seen with his name deep

Opposite: The Rev. Humphrey Gainsborough, the artist's brother, c. 1770-74

cut thereon, which I had done, previous to my sending it thither; it stands upon three brass claws like a mahogany table. [1] Three sisters, and one brother of Mr. Gainsborough's survive him, Mrs. Gibbons of Bath is the only one of his sisters, I am personally known to, and those who know Bath & Mrs. Gibbons, need not be told how respectable she is for her excellent understanding, and her exemplary life, two or three of his Nieces, Miss Gardeners are Milliners in Brock Street, Bath, and merit the notice of all those who wish to reward virtue, and patronize industry.

This is a hasty sketch of my departed friend and his family, written in one day and finished in one respect only, like his best pictures, *i.e.* at *one sitting*, for I think the finest head he ever painted, was that of his nephew, Mr. Dupont, and that was never touched but once, and that once the work of one hour, I admired it exceedingly, he gave it to me, and it may now be seen in Lady Bateman's dressing room, at my Lord Bateman's house the corner of Park Lane. [2] Mr. Gainsborough, soon after his marriage, had two daughters only, who are both living, the youngest is married to Mr. Fischer the celebrated performer on the OBOE, who

1. Lost 2. Probably the painting in the Tate, *c.* 1770-75

Opposite: Gainsborough Dupont, the artist's nephew, c. 1770-75

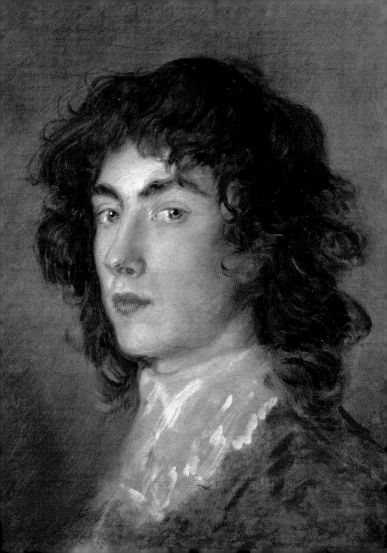

was a most beautiful woman in her youth; the eldest is unmarried, between whom, he has divided his fortune, his wife having as observed above, an annuity for her life, far beyond what she has spirit to spend, or generosity to bestow till she can keep it no longer. A Cancer broke forth from his neck, and his family imagine he died without knowing the danger he was in, or what occasioned it, but the truth is, he did not choose to know it, for he said to his Sister Gibbons, "if this *be a Cancer* I am a dead man," he then made his will, desired to be buried near his friend Kirby in Kew churchyard, and to have his name *only* cut upon his monumental stone; he died in the sixty-first year of his age, lamented by all who knew him, and has left a fame behind him which can NEVER DIE.

Since most part of these pages were printed off, I have seen a long and very excellent account of Mr. Gainsborough and his painting, in the *Gentleman's Magazine* for August last, there are however some trifling mistake which I think ought to be rectified, as well as an omission of my own. In page thirteen, I have mentioned *Thomas Peartree's head* (the head which so much attracted my notice in the garden of Ipswich) without explaining as the magazine has done, the cause of its being painted, and which Mr. Gainsborough related,

when I first visited him. At the bottom of his Ipswich garden, grew a fine bergamot pear tree, and while Mr. Gainsborough had his Palette and Brushes in his hand, *Thomas was* looking wishfully over the wall, and contemplating how he could come at some of the wind-falls, the sun shone just upon the top of Thomas's nose, and chin, while all the rest of his dejected countenance, appeared in shadow under his broad brimmed hat, which so struck Mr. Gainsborough's fancy (for such are the happy moments for poets and painters) that he snatched up his window shutter, and got *Thomas into his painting room*, before he had even tasted of the forbidden fruit. There is something so admirably well expressed in the magazine relative to Mr. Gainsborough's peculiar and superior manner of painting Portraits, that though I have always felt the truth of that observation, I could never account for it, and therefore I shall take the liberty of borrowing the editor's own words, for I never yet saw any other portrait painter who painted the mind, nay, the very soul of the living man. "He gives the feature and the shadow, so that it is sometimes not easy to say which is which; for the scumbling about the feature sometimes looks like feature itself; so that he shows the face in more points of view than one, and by that means it strikes everyone who has once seen the original that

it is a resemblance; and while the portrait with a rigid outline exhibits the countenance only in one disposition of mind, his gives it in many."

The Editor has very justly observed, that he failed in Mr. Garrick's Portrait,[1] and so he did in Foote's also;[2] and when I expressed my surprise, that he should have so done, he archly and instantly replied, "*Rot them for a couple of Rogues, they have every Body's faces but their own.*" It was one of those happy hours in which he painted *Thomas Peartree's head*, and that which he painted in one hour, and at one sitting of his ingenious nephew and scholar, Mr. Dupont, which as I said above, is in the possession of Lord Bateman, to whom I had the honour to present it, for the instant I saw it, I asked for it, and there was nothing I could ask of Gainsborough, which he could give *(except my own Portrait)* that he would have refused me. He gave me, after the death of his clergyman brother, all his finished and unfinished pieces of mechanism. The clock, an attempt at a perpetual motion, is not at the British Museum, but a most curious sundial is, and it is a piece of work worthy of notice; I parted with

1. 1766. Destroyed, but known through prints. Gainsborough painted a half-length portrait of Garrick, known in three versions, one at the National Portrait Gallery, London 2. Untraced

it reluctantly, but for reasons assigned above. The model of his steam engine met with the same fates as my landscape, I found it was too much perished, to be put in motion again, by being left exposed to the weather at his brother's house in Pall-Mall. That engine alone would have furnished a fortune to all the Gainsboroughs and their dependents, had not that unsuspicious, good-hearted man, let a cunning, de-signing artist see it, and who surreptitiously carried if off in his *mind's eye!* The clock however, shall visit *its Cousin, the Sundial,* but not till *I have done going.* The spiral channel in which a gilt ball rolls, to point out the hour, is cut from a solid pieces of brass, and I am told by a very great artist, that it is one of the truest and most accurate pieces of work he ever beheld. There is but one man now living whom I know, who can set this clock in motion, and that is the ingenious Mr. IRELAND, author of Henderson's life.

Mr. Gainsborough was not ignorant of his disor-der, but *pretended* to be so, for though he did not men-tion his suspicions to his children and Mr. Dupont, yet when his Sister Gibbons visited him, he said to her, "now if this be a Cancer, I am a dead man,' and then settled his affairs.* I cannot conclude, without

* This repetition is in the original.

mentioning his only surviving brother, because with all the genius which in a PECULIAR MANNER this *unique* family came into the world; he alone is unfortunate, I never saw him but once, and that is more than twenty years ago, but passing through Sudbury where he has always resided, I visited him as a friend of his brother's, but previous to my seeing him, I had sat an hour with his wife, and I think seven daughters, it was on a Sunday morning, and I found them all clean, but clothed in the most humble manner. These females *seemed all* endowed with good sense, but their countenances, even the children, were overcast with distress. I had taken an opportunity to give the eldest daughter a guinea (for I knew the character of the father) before he appeared, but the mother perceiving what I had done, said, God certainly sent you sir, for we have a piece of beef for dinner, but we have no bread to eat with it, I was shocked at this information, and asked her whether Mr. Gainsborough, her brother did not assist them, 'O yes!' said she, 'he often sends us five guineas, but the instant my husband gets it, he lays it all out in brass work to discover the longitude.' At that instant her longitudinal husband appeared, he would not suffer me even to tell him my name, or that I was a friend of his Brother's, but brought forth his curious brass work, and after showing me how *nearly* it was

completed, observed that *he only wanted* two guineas to buy brass to complete it. I could hardly determine whether his deranged imagination, or his wonderful ingenuity, was most to be admired, but I informed him that I had not capacity to conceive the genius of his unfinished work; and therefore wished him to show me such as were completed, he then showed me a cradle which rocked itself, a cuckoo, which would sing all the year round, and a wheel that turned round in a still bucket of water! he informed me, that he had visited Mr. Harrison and his time piece, but said he, 'Harrison *made no account of me* in my shabby coat, for he had Lords and Dukes with him, but after he had shown *the Lords* that a *great motion* to the machine, would no ways affect its regularity, I whispered him to give it *a gentle motion*,' Harrison started; and in re-turn, whispered him to stay, as he wanted to speak to him, after the rest of the company were gone. I then took my leave of this very eccentric and unfortunate man, without giving him the two guineas he solicited, and now lament that he has lost the aid of his excel-lent brother, for alas! without aid he cannot subsist, and must be verging upon, if not fourscore years of age, for I think he said he was twenty years older than his youngest brother. When a man at Colchester had made the first smoke jack, this curious man walked

over to see it, but the maker, prudently refused him, observing that probably he was an Artist himself, 'it is true' said Gainsborough, 'I am,' and then asked him what weight his jack would roast, 'a whole sheep' replied the artist, then said Gainsborough 'I will go home and make one that will roast a whole Ox,' and did so! ARTISTS; *and* ye LOVERS OF THE ARTS, I ask you should such a man as this, and the brother to the IMMORTAL THOMAS GAINBOROUGH, want ROAST MEAT, or bread to eat with it? GOD FORBID.

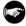 Mrs. G. has a great number of drawings, some of which are of Mrs. Fischer's pencil, which she *hoarded up,* observing *justly,* that they would fetch a *deal* of money when *Tom was dead* – A deal of good may they do her.

WILLIAM JACKSON

Character of Gainsborough

from

The Four Ages;
Together with Essays
on Various Subjects

1798

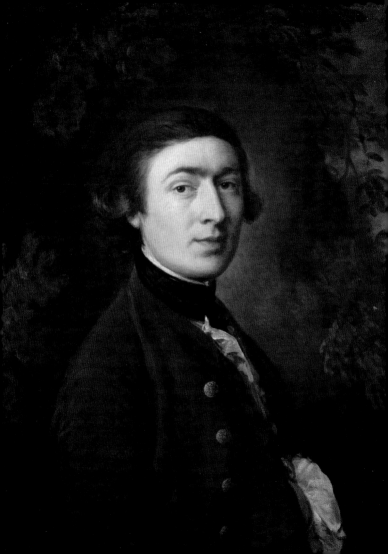

In the early part of my life I became acquainted with Thomas Gainsborough the painter; and as his character was, perhaps, better known to me than to any other person, I will endeavour to divest myself of every partiality, and speak of him as he really was. I am the rather induced to this, by seeing accounts of him and his works given by people who were unacquainted with either, and, consequently, have been mistaken in both.

Gainsborough's profession was painting, and music was his amusement—yet, there were times when music seemed to be his employment, and painting his diversion. As his skill in music has been celebrated, I will, before I speak of him as a painter, mention what degree of merit he professed as a musician.

When I first knew him he lived at Bath, where Giardini had been exhibiting his *then* unrivalled powers on the violin. His excellent performance made Gainsborough enamoured of that instrument; and conceiving, like the Servant-maid in the *Spectator*, that the music lay in the fiddle, he was frantic until he possessed the *very* instrument which had given him so much pleasure—but seemed much surprised that the music of it remained behind with Giardini!

Opposite: Self-portrait, c.1759

He had scarcely recovered this shock (for it was a great one to *him*) when he heard Abel on the viol di gamba. The violin was hung on the willow—Abel's viol di gamba was purchased, and the house resounded with melodious thirds and fifths from "morn to dewy eve!" Many an Adagio and many a Minuet were begun, but none completed—this was wonderful, as it was Abel's *own* instrument, and therefore *ought* to have produced Abel's own music!

Fortunately, my friend's passion had now a fresh object—Fischer's hautboy—but I do not recollect that he deprived Fischer of his instrument: and though he procured a hautboy, I never heard him make the least attempt on it. Probably his ear was too delicate to bear the disagreeable sounds which necessarily attend the first beginnings on a wind-instrument. He seemed to content himself with what he heard in public, and getting Fischer to play to him in private—not on the hautboy, but the violin—but this was a profound secret, for Fischer knew that his reputation was in danger if he pretended to excel on two instruments.*

* It was at this time that I heard Fischer play a solo on the violin, and accompany himself on the same instrument – the air of the solo was executed with the bow, and the accompaniment *pizzicato* with the unemployed fingers of his left hand.

Opposite: Carl Friedrich Abel, c. 1765

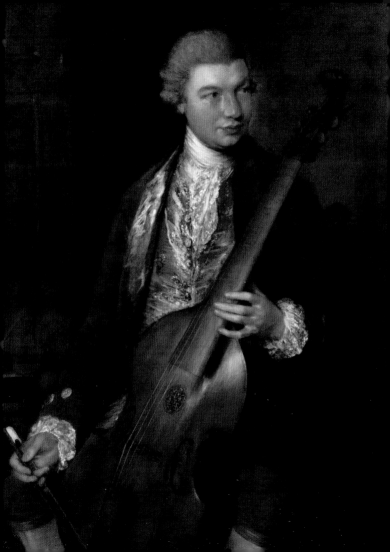

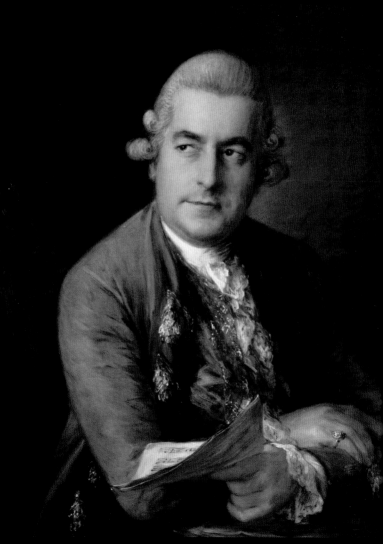

The next time I saw Gainsborough it was in the character of King David. He had heard a harper at Bath—the performer was soon left harpless—and now Fischer, Abel, and Giardini were all forgotten—there was nothing like chords and arpeggios! He really stuck to the harp long enough to play several airs with variations, and, in a little time, would nearly have exhausted all the pieces usually performed on an instrument incapable of modulations (this was not a pedal-harp), when another visit from Abel brought him back to the viol di gamba.

He now saw the imperfection of sudden sounds that instantly die away—if you want *staccato*, it was to be had by a proper management of the bow, and you might also have notes as long as you please. The viol di gamba is the only instrument, and Abel the prince of musicians!

This, and occasionally a little flirtation with the fiddle, continued some years; when, as ill-luck would have it, he heard Crosdill—but, by some irregularity of conduct, for which I cannot account, he neither took up, nor bought, the violoncello. All his passion for the Bass was vented in descriptions of Crosdill's tone and bowing, which was rapturous and enthusiastic to the last degree.

Opposite: Johann Christian Bach, c. 1776

More years now passed away, when upon seeing a Theorbo in a pictures of Vandyke's; he concluded (perhaps, because it was finely painted) that the Theorbo must be a fine instrument. He recollected to have heard of a German professor, who, though no more, I shall forbear to name—ascended *per varios gradus* to his garret, where he found him at dinner upon a roasted apple, and smoking a pipe — *** says he, I am come to buy your lute—

 '*To pay my lude!*'
Yes—come, name your price, and here is your money.
 '*I cannod shell my lude!*'
No, not for a guinea or two, but by G— you must sell it.
 '*May lude ish wert much monny! It ish wert ten guinea.*'
That it is—see, here is the money.
 '*Well—if I musht—but you will not take it away yourshelf?*'
Yes, yes—good bye ***.
(After he had gone down he came up again)
***, I have done but half my errand—What is your lute worth, if I have not your book?
 '*What poog, Maishter Gainsporough?*'

Why the book of airs you have composed for the lute.

'Ah, py cot I can never part wit my poog!'

Poh! you can make another at any time—this is the book I mean (putting it in his pocket)

'Ah py cot, I cannot'–

Come, come, here's another ten guineas for your book—so, once more, good day t'ye—(descends again, and again comes up). But what use is your book to me, if I don't understand it?—and your lute—you may take it again, if you won't teach me to play on it—Come home with me, and give my first lesson—

'I will gome to marrow'

You must come now.

'I musht tress myshelf.'

For what? You are the best figure I have seen to day—

'Ay musht be shave'—

I honour your beard!

'Ay musht bud on my wik'—

D—n your wig! your cap and beard become you! do you think if Vandyke was to paint you he'd let you be shaved?—

In this manner he frittered away his musical

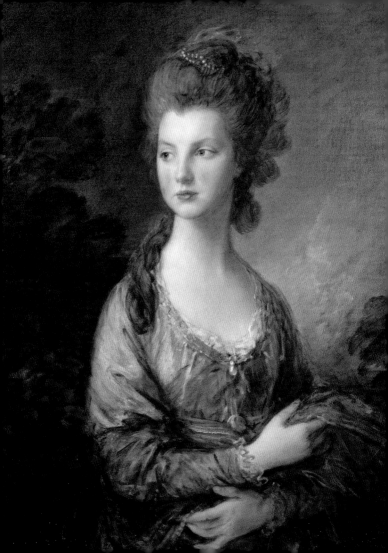

talents; and though possessed of ear, taste, and genius, he never had application enough to learn his notes. He scorned to take the first step, the second was of course out of his reach; and the summit became unattainable.

As a painter, his abilities may be considered in three different departments.

Portrait,

Landscape, and

Groups of Figures—to which must be added his Drawings.

To take these in the abovementioned order.

The first consideration in a portrait, especially to the purchaser, is, that it be a perfect likeness of the sitter—in this respect, his skill was unrivalled—the next point is, that it is a good picture—here, he has as often failed as succeeded. He failed by affecting a thin washy colouring, and a hatching style of penciling—but when, from accident or choice, he painted in the manly substantial style of Vandyke, he was very little, if at all, his inferior. It shows a great defect in judgement, to be from choice, wrong, when we know what

Opposite: The Hon. Mrs. Thomas Graham, c. 1775-77

is right. Perhaps, his best portrait is that known among the painters by the name of the *Blue-boy*—it was in the possession of Mr. Buttall, near Newport-market.

There are three different eras in his landscapes—his first manner was an imitation of Ruisdael, with more various colouring—the second, was an extravagant looseness of pencilling; which, though reprehensible, none but a great master can possess—his third manner, was a solid firm style touch.

At this last period he possessed his greatest powers, and was (what every painter is at some time or other) fond of varnish. This produced the usual effects—improved the picture for two or three months; then ruined it for ever! With all his excellence in this branch of the art, he was a great mannerist—but the worst of his pictures have a value, from the facility of execution—which excellence I shall again mention.

His groups of figures are, for the most part, very pleasing, though unnatural—for a town-girl, with her clothes in rags, is not a ragged country-girl. Notwithstanding this remark, there are numberless instances of his groups at the door of a cottage, or by a fire in a wood, &c. that are so pleasing as to disarm criticism. He sometimes (like Murillo) gave interest to a single

Opposite: Figures before a cottage, c. 1772

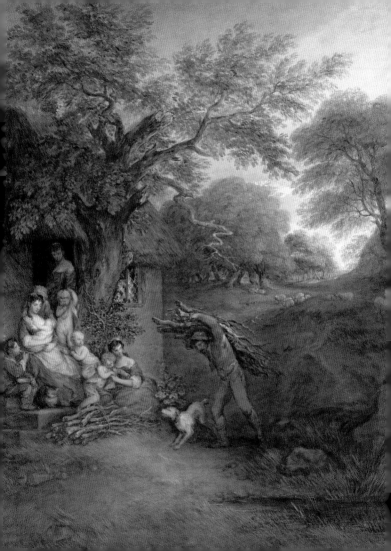

figure—his *Shepherd's boy*,[1] *Woodman*,[2] *Girl and pigs*[3] are equal to the best pictures on such subjects—his *Fighting dogs*,[4] *Girl warming herself*,[5] and some others, show his great powers in this style of painting. The very distinguished rank the *Girl and pigs* held at Mr. Calonne's sale, in company with some of the best pictures of the best masters, will fully justify a commendation which might else seem extravagant.

If I were to rest his reputation upon one point, it should be on his Drawings. No man ever possessed methods so various in producing effect, and all excellent—his washy, hatching style, was here in its proper element. The subject which is scarce enough for a picture, is sufficient for a drawing, and the hasty loose handling, which in painting is poor, is rich in a transparent wash of bistre and Indian ink. Perhaps the quickest effects ever produced, were in some of his drawings—and this leads me to take up again his facility of execution.

Many of his pictures have no other merit than this

1. Untraced 2. 1787. Lost in a fire (1810) but known by copies and a mezzotint 3. 1782, Castle Howard (once owned by Reynolds) 4. *Two shepherd boys with dogs fighting* (1783), London, Kenwood House 5. Probably *Children by the fire* (1787), lost but known by a mezzotint, pendant to *A boy with a cat – Morning*, ill. p. 115

Opposite: Two shepherd boys with dogs fighting, 1783

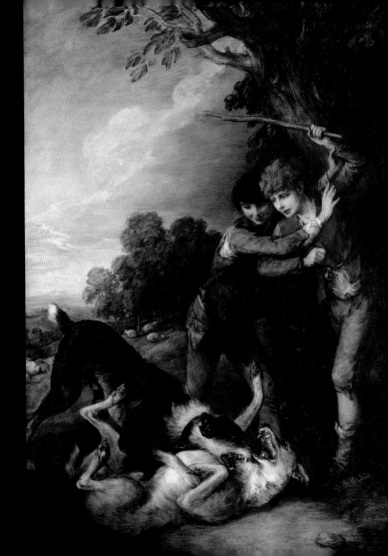

facility; and yet, having it, are undoubtedly valuable. His drawings almost rest on this quality alone for their value; but possessing it in an eminent degree (and as no drawing can have any merit where it is wanting) his works, therefore, in this branch of the art, approach nearer to perfection than his painting.

If the term *facility* explain not itself, instead of a definition, I will illustrate it.

Should a performer of middling execution on the violin, contrive to get through his piece, the most that can be said, is, that he has not failed in his attempt. Should Cramer perform the same music, it would be so much within his powers, that it would be executed with ease. Now, the superiority of pleasure, which arises from the execution of a Cramer, is enjoyed from the facility of a Gainsborough. A poor piece performed by one, or a poor subject taken by the other, give more pleasure by the *manner* in which they are treated, than a good piece of music, and a sublime subject in the hands of artists that have not the means by which effects are produced, *in subjection to them.* To a good painter or musician this illustration was needless; and yet, by them *only*, perhaps, it will be felt and understood.

By way of addition to this sketch of Gainsborough, let me mention a few miscellaneous particulars.

He had no relish for historical painting—he never sold, but always gave away his drawings; commonly to persons who were perfectly ignorant of their value.* He hated harpsichord and the piano-forte. He disliked singing, particularly in parts. He detested reading; but was so like Sterne in his Letters, that, if it were not for an originality that could be copied from no one, it might be supposed that he had formed his style upon a close imitation of that author. He had as much pleasure in looking at a violin as in hearing it—I have seen him for many minutes surveying, in silence, the perfection of an instrument, from the just proportion of the model, and beauty of the workmanship.

His conversation was sprightly, but licentious—his favourite subjects were music and painting, which he treated in a manner peculiarly his own. The common topics, or any of a superior cast, he thoroughly hated, and always interrupted by some stroke of wit or humour.

The indiscriminate admirers of my late friend will consider this sketch of his character as far beneath his

* He presented twenty drawings to a lady, who pasted them to the wainscot of her dressing-room. Sometime after she left the house: the drawings, of course, become the temporary property of every tenant.

merit; but it must be remembered, that my wish was not to make it perfect, but just. The same principle obliges me to add—that as to his common acquaintance he was sprightly and agreeable, so to his intimate friends he was sincere and honest, and that his heart was always alive to every feeling of honour and generosity.

He died with this expression—" We are all going to Heaven, and Vandyke is of the party"—Strongly expressive of a good heart, a quiet conscience, and a love for his profession, which only left him with his life.

Opposition between
Reynolds and Gainsborough
from *Character of Reynolds*

With the same freedom that I have sketched the character of those two great painters, I will set their merits *in opposition* to each other – for the usual word of *parallel* will not serve the purpose.

Sir Joshua was always in the way of information and improvement, by constantly associating with men of talents and learning.

Gainsborough avoided the company of literary

men, who were his aversion – he was better pleased to give, than to receive information.

Sir J. (not because he was deaf) wanted all idea and perception of music, being perfectly destitute of ear.

G. had as correct an ear as possible, and great enjoyment of exquisite instrumental performance – vocal music he did not relish.

Sir J. considered historical painting as the great point of perfection to which artists should aspire, and was himself in the first rank of excellence.

G. either wanted conception or taste, to relish historical painting, which he always considered as out of his way, and thought he should make himself ridiculous by attempting it.

Sir J. never painted a landscape, except the two views from his villa at Richmond – subjects altogether improper for a picture, and by no means happily executed – the little touches of landscape which he frequently introduced in the background of portraits were in a much superior style, and well calculated for the effect intended.

G. painted some hundreds of landscapes of different degrees of merit – some, little better than washed drawings, others very rich – but they all possessed that freedom of penciling which will for ever make them valuable in the eye of an artist.

CHARACTER OF GAINSBOROUGH

Sir J. never painted cattle, shipping or other subordinate subjects.

G. painted cattle of all denominations very finely. He never pretended to the correctness of rigging, &c. but I have seen some general effects of sea, sea-coast, and vessels, that have been truly masterly.

Sir J. in portraits was different according to the area of his practice – in his best times his pictures possessed an elegance of design – picturesque draperies – beautiful disposition of parts and circumstances; and certainly were greatly superior to those of all other artists.

G. was always sure of a likeness – not frequently happy in attitude or disposition of parts. His pencilling was sometimes thin and hatchy, sometimes rich and full; but always possessing a facility of touch, which as in his landscapes, makes the worst of his pictures valuable.

Sir J. made very few drawings – it is natural to suppose that he made some; but as I never saw any, they cannot be supposed to be numerous, nor can I say any thing upon the subject.

Of Gainsborough, on the contrary, perhaps, there are more drawings existing than of any other artist,

Opposite: Coastal scene with shipping and cattle, 1781-82

ancient or modern. I must have seen at least a thousand, not one of which but possesses merit, and some in a transcendent degree – two small ones in slight tint varnished, in the possession of Mr. Baring of Exeter, are invaluable![1]

Sir J. as an author, wrote two or three papers in the Idler, some Notes for Johnson's Edition of Shakespeare, and a few other incidental performances. His greatest literary work are his Discourses at the Royal Academy, which are replete with classical knowledge in his art – original observations – acute remarks in the works of others, and general taste and discernment. In his Eloge on Gainsborough are traits of kindness and goodness of heart, exceedingly affecting to those who knew the subject! His Discourses are collected and published together – they will be most valued by those who are best qualified to judge of their excellence.

G. so far from writing, scarcely ever read a book – but, for a letter to an intimate friend, he had few equals, and no superior. It was like his conversation, gay, lively – fluttering round subjects which he just touched, and away to another – expressing his

1. Untraced

Opposite: A milkmaid climbing a stile, c. 1750

thoughts with so little reserve, that his correspondents considering the letter as a part of their friend, had never the heart to burn it!

Sir Joshua's character was most solid – Gainsborough's most lively – Sir J. wished to reach the foundation of opinions. The swallow, in her airy course, never skimmed a surface so light as Gainsborough touched all subjects – that bird could not fear drowning more, than he dreaded deep disquisitions. Hitherto we have marked the difference of these great men. In one thing, and, I believe, in one only perfectly agreed – they each possessed a heart full-fraught with the warmest wishes for the advancement of the divine art they possessed – of kindness to their friends – and general benevolence to men of merit, wherever found, and however distinguished.

SIR JOSHUA REYNOLDS

Character of Gainsborough:
his excellencies and defects

from

Discourse XIV, delivered to the Students
of the Royal Academy, on the
Distribution of the Prizes

December 10, 1788

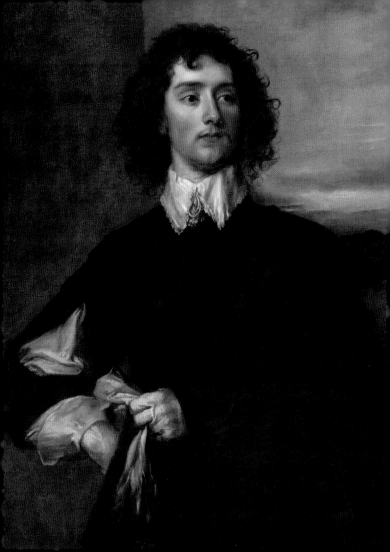

In the study of our art, as in the study of all arts, something is the result of *our own* observation of nature; something, and that not a little, the effect of the example of those who have studied the same nature before us, and who have cultivated before us the same art, with diligence and success. The less we confine ourselves in the choice of those examples, the more advantage we shall derive from them; and the nearer we shall bring our performances to a correspondence with nature and the great general rules of art. When we draw our examples from remote and revered antiquity—with some advantage, undoubtedly, in that selection—we subject ourselves to some inconveniencies. We may suffer ourselves to be too much led away by great names, and to be too much subdued by overbearing authority. Our learning, in that case, is not so much an exercise of our judgment as a proof of our docility. We find ourselves, perhaps, too much overshadowed; and the character of our pursuits is rather distinguished by the tameness of the follower than animated by the spirit of emulation. It is sometimes of service that our examples should be *near* us; and such as raise a reverence, sufficient to induce us carefully to observe them, yet not

Opposite: Sir Thomas Hanmer, after Anthony van Dyck, c. 1775

so great as to prevent us from engaging with them in something like a generous contention.

We have lately lost Mr. Gainsborough, one of the greatest ornaments of our Academy. It is not our business here to make Panegyrics on the living, or even on the dead who were of our body. The praise of the former might bear the appearance of adulation; and the latter of untimely justice; perhaps of envy to those whom we have still the happiness to enjoy, by an oblique suggestion of invidious comparisons. In discoursing, therefore, on the talents of the late Mr. Gainsborough, my object is, not so much to praise or to blame him, as to draw from his excellencies and defects matter of instruction to the Students in our Academy. If ever this nation should produce genius sufficient to acquire to us the honourable distinction of an English School, the name of Gainsborough will be transmitted to posterity, in the history of the art, among the very first of that rising name. That our reputation in the Arts is now only rising must be acknowledged; and we must expect our advances to be attended with old prejudices, as adversaries, and not as supporters; standing in this respect in a very different situation from the late artists of the Roman School, to whose reputation ancient prejudices have certainly contributed; the way was prepared for them,

and they may be said rather to have lived in the reputation of their country than have contributed to it; whilst whatever celebrity is obtained by English Artists can arise only from the operation of a fair and true comparison. And when they communicate to their country a share of their reputation, it is a portion of fame not borrowed from others, but solely acquired by their own labour and talents. As Italy has undoubtedly a prescriptive right to an admiration bordering on prejudice, as a soil peculiarly adapted, congenial, and, we may add, destined to the production of men of great genius in our Art, we may not unreasonably suspect that a portion of the great fame of some of their late artists has been owing to the general readiness and disposition of mankind to acquiesce in their original prepossessions in favour of the productions of the Roman School.

On this ground, however unsafe, I will venture to prophesy, that two of the last distinguished painters of that country, I mean Pompeo Batoni and Raphael Mengs, however great their names may at present sound in our ears, will very soon fall into the rank of Imperiale, Sebastiano Conca, Placido Constanza, Masaccio, and the rest of their immediate predecessors; whose names, though equally renowned in their lifetime, are now fallen into what is little short of total

oblivion. I do not say that those painters were not supe-
rior to the artist I allude to, and whose loss we lament,
in a certain routine of practice, which, to the eyes of
common observers, has the air of a learned composi-
tion, and bears a sort of superficial resemblance to
the manner of the great men who went before them.
I know this perfectly well; but I know likewise, that a
man looking for real and lasting reputation must un-
learn much of the commonplace method so observ-
able in the works of the artists whom I have named.
For my own part, I confess, I take more interest in and
am more captivated with the powerful impression of
nature which Gainsborough exhibited in his portraits
and in his landscapes, and the interesting simplicity
and elegance of his little ordinary beggar-children,
than with any of the works of that School, since the
time of Andrea Sacchi, or perhaps we may say Carlo
Maratti; two painters who may truly be said to be
ULTIMI ROMANORUM.

I am well aware how much I lay myself open to
the censure and ridicule of the academical profes-
sors of other nations, in preferring the humble at-
tempts of Gainsborough to the works of those regu-
lar graduates in the great historical style. But we have

Opposite: A boy with a cat – Morning, 1787

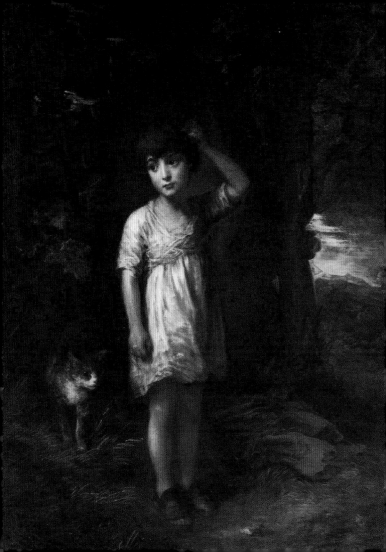

the sanction of all mankind in preferring genius in a lower rank of art to feebleness and insipidity in the highest.

It would not be to the present purpose, even if I had the means and materials, which I have not, to enter into the private life of Mr. Gainsborough. The history of his gradual advancement, and the means by which he acquired such excellence in his art, would come nearer to our purposes and wishes, if it were by any means attainable; but the slow progress of advancement is in general imperceptible to the man himself who makes it; it is the consequence of an accumulation of various ideas which his mind has received, he does not perhaps know how or when. Sometimes, indeed, it happens that he may be able to mark the time when, from the sight of a picture, a passage in an author, or a hint in conversation, he has received, as it were, some new and guiding light, something like inspiration, by which his mind has been expanded; and is morally sure that his whole life and conduct has been affected by that accidental circumstance. Such interesting accounts we may, however, sometimes obtain from a man who has acquired an uncommon habit of self-examination, and has attended to the progress of his own improvement.

It may not be improper to make mention of some

of the customs and habits of this extraordinary man; points which come more within the reach of an observer: I, however, mean such only as are connected with his art, and indeed were, as I apprehend, the causes of his arriving to that high degree of excellence which we see and acknowledge in his works. Of these causes we must state, as the fundamental, the love which he had to his art; to which, indeed, his whole mind appears to have been devoted, and to which everything was referred; and this we may fairly conclude from various circumstances of his life, which were known to his intimate friends. Among others, he had a habit of continually remarking to those who happened to be about him whatever peculiarity of countenance, whatever accidental combination of figure, or happy effects of light and shadow, occurred in prospects, in the sky, in walking the streets, or in company. If, in his walks, he found a character that he liked, and whose attendance was to be obtained, he ordered him to his house: and from the fields he brought into his painting-room stumps of trees, weeds, and animals of various kinds; and designed them, not from memory, but immediately from the objects. He even framed a kind of model of landscapes on his table; composed

Overleaf: The road from market, 1767-68

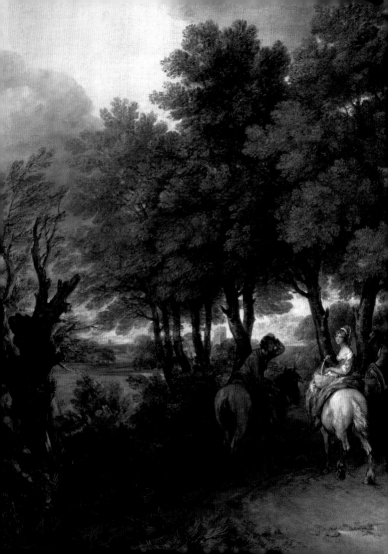

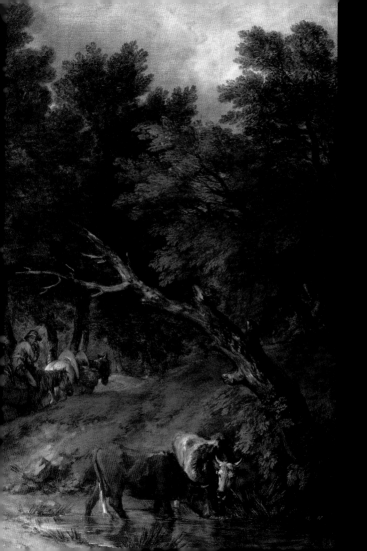

of broken stones, dried herbs, and pieces of looking-glass, which he magnified and improved into rocks, trees, and water. How far this latter practice may be useful in giving hints, the professors of landscape can best determine. Like every other technical practice, it seems to me wholly to depend on the general talent of him who uses it. Such methods may be nothing better than contemptible and mischievous trifling; or they may be aids. I think, upon the whole, unless we constantly refer to real nature, that practice may be more likely to do harm than good. I mention it only, as it shows the solicitude and extreme activity which he had about everything that related to his art; that he wished to have his objects embodied, as it were, and distinctly before him; that he neglected nothing which could keep his faculties in exercise, and derived hints from every sort of combination.

We must not forget, whilst we are on this subject, to make some remarks on his custom of painting by night, which confirms what I have already mentioned, his great affection to his art; since he could not amuse himself in the evening by any other means so agreeable to himself. I am, indeed, much inclined to believe that it is a practice very advantageous and improving to an artist; for by this means he will acquire a new and a higher perception of what is great and beautiful in

nature. By candle-light, not only objects appear more beautiful, but from their being in a greater breadth of light and shadow, as well as having a greater breadth and uniformity of colour, nature appears in a higher style; and even the flesh seems to take a higher and richer tone of colour. Judgment is to direct us in the use to be made of this method of study; but the method itself is, I am sure, advantageous. I have often imagined that the two great colourists, Titian and Correggio, though I do not know that they painted by night, formed their high ideas of colouring from the effects of objects by this artificial light; but I am more assured that whoever attentively studies the first and best manner of Guercino, will be convinced that he either painted by this light, or formed his manner on this conception.

Another practice Gainsborough had, which is worth mentioning, as it is certainly worthy of imitation; I mean his manner of forming all the parts of his picture together; the whole going on at the same time, in the same manner as nature creates her works. Though this method is not uncommon to those who have been regularly educated, yet probably it was suggested to him by his own natural sagacity. That this custom is not universal appears from the practice of a painter whom I have just mentioned, Pompeo Batoni,

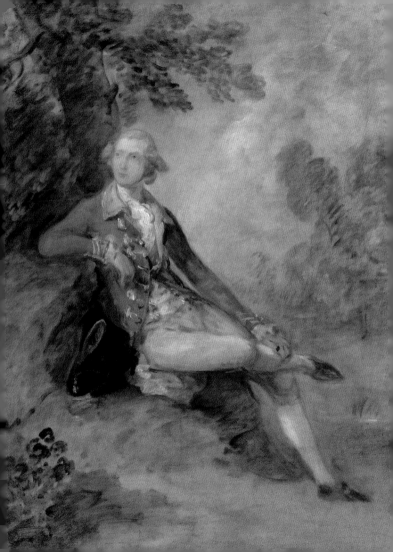

who finished his historical pictures part after part, and in his portraits completely finished one feature before he proceeded to another. The consequence was as might be expected; the countenance was never well expressed; and, as the painters say, the whole was not well put together.

The first thing required to excel in our art, or I believe in any art, is not only a love for it, but even an enthusiastic ambition to excel in it. This never fails of success proportioned to the natural abilities with which the artist has been endowed by Providence. Of Gainsborough, we certainly know, that his passion was not the acquirement of riches, but excellence in his art; and to enjoy that honourable fame which is sure to attend it.—That *he felt this ruling passion strong in death* I am myself a witness. A few days before he died, he wrote me a letter, to express his acknowledgments for the good opinion I entertained of his abilities, and the manner in which (he had been informed) I always spoke of him; and desired he might see me once more before he died. I am aware how flattering it is to myself to be thus connected with the dying testimony which this excellent painter bore to his art. But I cannot prevail on myself to suppress that I was

Opposite: Edward Augustus, Duke of Kent, c. 1787

not connected with him, by any habits of familiarity: if any little jealousies had subsisted between us, they were forgotten in those moments of sincerity; and he turned towards me as one who was engrossed by the same pursuits, and who deserved his good opinion, by being sensible of his excellence. Without entering into a detail of what passed at this last interview, the impression of it upon my mind was, that his regret at losing life was principally the regret of leaving his art; and more especially as he now began, he said, to see what his deficiencies were; which, he said, he flattered himself in his last works were in some measure supplied.

When such a man as Gainsborough arrives to great fame, without the assistance of an academical education, without travelling to Italy, or any of those preparatory studies which have been so often recommended, he is produced as an instance how little such studies are necessary; since so great excellence may be acquired without them. This is an inference not warranted by the success of any individual; and I trust it will not be thought that I wish to make this use of it.

It must be remembered that the style and department of art which Gainsborough chose, and in which he so much excelled, did not require that he should go out of his own country for the objects of his study;

they were everywhere about him; he found them in the streets and in the fields, and from the models thus accidentally found, he selected with great judgment such as suited his purpose. As his studies were directed to the living world principally, he did not pay a general attention to the works of the various masters, though they are, in my opinion, always of great use, even when the character of our subject requires us to depart from some of their principles. It cannot be denied, that excellence in the department of the art which he professed may exist without them; that in such subjects, and in the manner that belongs to them, the want of them is supplied, and more than supplied, by natural sagacity, and a minute observation of particular nature. If Gainsborough did not look at nature with a poet's eye, it must be acknowledged that he saw her with the eye of a painter; and gave a faithful, if not a poetical, representation of what he had before him.

Though he did not much attend to the works of the great historical painters of former ages, yet he was well aware that the language of the art—the art of imitation—must be learned somewhere; and as he knew that he could not learn it in an equal degree from his contemporaries, he very judiciously applied himself to the Flemish School, who are undoubtedly

the greatest masters of one necessary branch of art; and he did not need to go out of his own country for examples of that school; from that he learnt the harmony of colouring, the management and disposition of light and shadow, and every means which the masters of it practised, to ornament and give splendour to their works. And to satisfy himself as well as others how well he knew the mechanism and artifice which they employed to bring out that tone of colour which we so much admire in their works, he occasionally made copies from Rubens, Teniers, and Vandyke, which it would be no disgrace to the most accurate connoisseur to mistake, at the first sight, for the works of those masters. What he thus learned, he applied to the originals of nature, which he saw with his own eyes; and imitated, not in the manner of those masters, but in his own.

Whether he most excelled in portraits, landscapes, or fancy pictures, it is difficult to determine: whether his portraits were most admirable for exact truth of resemblance, or his landscapes for a portrait-like representation of nature, such as we see in the works of Rubens, Ruisdael, and others of those schools. In his fancy pictures, when he had fixed on his object of

Opposite: Country lane with gypsies resting, c. 1760-65

imitation, whether it was the mean and vulgar form of a wood-cutter, or a child of an interesting character, as he did not attempt to raise the one, so neither did he lose any of the natural grace and elegance of the other; such a grace, and such an elegance, as are more frequently found in cottages than in courts. This excellence was his own, the result of his particular observation and taste; for this he was certainly not indebted to the Flemish School, nor, indeed, to any school; for his grace was not academical or antique, but selected by himself from the great school of nature; and there are yet a thousand modes of grace, which are neither theirs, nor his, but lie open in the multiplied scenes and figures of life, to be brought out by skilful and faithful observers.

Upon the whole, we may justly say, that whatever he attempted he carried to a high degree of excellence. It is to the credit of his good sense and judgment, that he never did attempt that style of historical painting for which his previous studies had made no preparation.

And here it naturally occurs to oppose the sensible conduct of Gainsborough in this respect to that of our late excellent Hogarth, who, with all his extraordinary talents, was not blessed with this knowledge of his own deficiency, or of the bounds which were

set to the extent of his own powers. After this admirable artist had spent the greater part of his life in an active, busy, and, we may add, successful attention to the ridicule of life; after he had invented a new species of dramatic painting, in which probably he will never be equalled, and had stored his mind with infinite materials to explain and illustrate the domestic and familiar scenes of common life, which were generally, and ought to have been always, the subject of his pencil; he very imprudently, or rather presumptuously, attempted the great historical style, for which his previous habits had by no means prepared him: he was indeed so entirely unacquainted with the principles of this style, that he was not even aware that any artificial preparation was at all necessary. It is to be regretted that any part of the life of such a genius should be fruitlessly employed. Let his failure teach us not to indulge ourselves in the vain imagination, that by a momentary resolution we can give either dexterity to the hand, or a new habit to the mind.

I have, however, little doubt, but that the same sagacity which enabled those two extraordinary men to discover their true object, and the peculiar excellence of that branch of art which they cultivated, would have been equally effectual in discovering the

principles of the higher style, if they had investigated those principles with the same eager industry which they exerted in their own department. As Gainsborough never attempted the heroic style, so neither did he destroy the character and uniformity of his own style by the idle affectation of introducing mythological learning in any of his pictures. Of this boyish folly we see instances enough, even in the works of great painters. When the Dutch School attempt this poetry of our art in their landscapes, their performances are beneath criticism; they become only an object of laughter. This practice is hardly excusable even in Claude Lorrain, who had shown more discretion if he had never meddled with such subjects.

Our late ingenious Academician, Wilson, has, I fear, been guilty, like many of his predecessors, of introducing gods and goddesses, ideal beings, into scenes which were by no means prepared to receive such personages. His landscapes were in reality too near common nature to admit supernatural objects. In consequence of this mistake, in a very admirable picture of a storm, which I have seen of his hand, many figures are introduced in the foreground, some in apparent distress, and some struck dead, as a spectator would naturally suppose, by the lightning; had not the painter injudiciously (as I think) rather chosen

that their death should be imputed to a little Apollo, who appears in the sky, with his bent bow, and that those figures should be considered as the children of Niobe.[1]

To manage a subject of this kind, a peculiar style of art is required; and it can only be done without impropriety, or even without ridicule, when we adapt the character of the landscape, and that, too, in all its parts, to the historical or poetical representation. This is a very difficult adventure, and it requires a mind thrown back two thousand years, and, as it were, naturalised in antiquity, like that of Nicolas Poussin, to achieve it. In the picture alluded to, the first idea that presents itself is that of wonder, at seeing a figure in so uncommon a situation as that in which the Apollo is placed; for the clouds on which he kneels have not the appearance of being able to support him; they have neither the substance nor the form fit for the receptacle of a human figure; and they do not possess in any respect that romantic character which is appropriated to such an object, and which alone can harmonise with poetical stories.

It appears to me that such conduct is no less

1. Richard Wilson, *The Destruction of the Children of Niobe*, 1761. Yale Center for British Art, New Haven

absurd than if a plain man, giving a relation of real distress occasioned by an inundation accompanied with thunder and lightning, should, instead of simply relating the event, take it into his head, in order to give a grace to his narration, to talk of Jupiter Pluvius, or Jupiter and his thunderbolts, or any other figurative idea; an intermixture which, though in poetry, with its proper preparations and accompaniments, it might be managed with effect, yet in the instance before us would counteract the purpose of the narrator, and, instead of being interesting, would be only ridiculous.

The Dutch and Flemish style of landscape, not even excepting those of Rubens, is unfit for poetical subjects; but to explain in what this ineptitude consists, or to point out all the circumstances that give nobleness, grandeur, and the poetic character, to style, in landscape, would require a long discourse of itself; and the end would be then perhaps but imperfectly attained. The painter who is ambitious of this perilous excellence must catch his inspiration from those who have cultivated with success the poetry, as it may be called, of the art; and they are few indeed.

I cannot quit this subject without mentioning two examples which occur to me at present, in which the poetical style of landscape may be seen happily

executed: the one is *Jacob's Dream*, by Salvator Rosa,[1] and the other *The Return of the Ark from Captivity*, by Sebastian Bourdon.[2] With whatever dignity those histories are presented to us in the language of Scripture, this style of painting possesses the same power of inspiring sentiments of grandeur and sublimity, and is able to communicate them to subjects which appear by no means adapted to receive them. A ladder against the sky has no very promising appearance of possessing a capacity to excite any heroic ideas; and the Ark, in the hands of a second-rate master, would have little more effect than a common waggon on the highway: yet those subjects are so poetically treated throughout, the parts have such a correspondence with each other, and the whole and every part of the scene is so visionary, that it is impossible to look at them without feeling, in some measure, the enthusiasm which seems to have inspired the painters.

By continual contemplation of such works, a sense of the higher excellencies of art will by degrees dawn on the imagination; at every review that sense will become more and more assured, until we come to enjoy a sober certainty of the real existence (if I may so

1. *c.*1665, Chatsworth House, Derbyshire 2. 1659, National Gallery, London

express myself) of those almost ideal beauties; and the artist will then find no difficulty in fixing in his mind the principles by which the impression is produced; which he will feel and practise, though they are perhaps too delicate and refined, and too peculiar to the imitative art, to be conveyed to the mind by any other means.

To return to Gainsborough; the peculiarity of his manner, or style, or we may call it—the language in which he expressed his ideas, has been considered by many as his greatest defect. But without altogether wishing to enter into the discussion—whether this peculiarity was a defect or not, intermixed, as it was, with great beauties, of some of which it was probably the cause, it becomes a proper subject of criticism and inquiry to a painter.

A novelty and peculiarity of manner, as it is often a cause of our approbation, so likewise it is often a ground of censure; as being contrary to the practice of other painters, in whose manner we have been initiated, and in whose favour we have perhaps been prepossessed from our infancy; for, fond as we are of novelty, we are upon the whole creatures of habit. However, it is certain, that all those odd scratches

Opposite: The Marsham Children. 1787

and marks, which, on a close examination, are so observable in Gainsborough's pictures, and which even to experienced painters appear rather the effect of accident than design: this chaos, this uncouth and shapeless appearance, by a kind of magic, at a certain distance assumes form, and all the parts seem to drop into their proper places, so that we can hardly refuse acknowledging the full effect of diligence, under the appearance of chance and hasty negligence. That Gainsborough himself considered this peculiarity in his manner, and the power it possesses of exciting surprise, as a beauty in his works, I think may be inferred from the eager desire which we know he always expressed, that his pictures, at the Exhibition, should be seen near, as well as at a distance.

The slightness which we see in his best works cannot always be imputed to negligence. However they may appear to superficial observers, painters know very well that a steady attention to the general effect takes up more time, and is much more laborious to the mind, than any mode of high finishing, or smoothness, without such attention. His *handling*, *the manner of leaving the colours*, or, in other words, the methods he used for producing the effect, had very much the appearance of the work of an artist who had never learned from others the usual and regular

practice belonging to the art; but still, like a man of strong intuitive perception of what was required, he found out a way of his own to accomplish his purpose.

It is no disgrace to the genius of Gainsborough to compare him to such men as we sometimes meet with, whose natural eloquence appears even in speaking a language which they can scarce be said to understand; and who, without knowing the appropriate expression of almost any one idea, contrive to communicate the lively and forcible impressions of an energetic mind.

I think some apology may reasonably be made for his manner without violating truth, or running any risk of poisoning the minds of the younger students, by propagating false criticism, for the sake of raising the character of a favourite artist. It must be allowed, that this hatching manner of Gainsborough did very much contribute to the lightness of effect which is so eminent a beauty in his pictures; as, on the contrary, much smoothness, and uniting the colours, is apt to produce heaviness. Every artist must have remarked how often that lightness of hand which was in his dead colour, or first painting, escaped in the finishing when he had determined the parts with more preci-sion; and another loss he often experiences, which is of greater consequence: whilst he is employed in the detail, the effect of the whole together is either

forgotten or neglected. The likeness of a portrait, as I have formerly observed, consists more in preserving the general effect of the countenance than in the most minute finishing of the features, or any of the particular parts. Now Gainsborough's portraits were often little more, in regard to finishing, or determining the form of the features, than what generally attends a dead colour; but as he was always attentive to the general effect, or whole together, I have often imagined that this unfinished manner contributed even to that striking resemblance for which his portraits are so remarkable. Though this opinion may be considered as fanciful, yet I think a plausible reason may be given why such a mode of painting should have such an effect. It is presupposed that in this undetermined manner there is in the general effect enough to remind the spectator of the original; the imagination supplies the rest, and perhaps more satisfactorily to himself, if not more exactly, than the artist, with all his care, could possibly have done. At the same time it must be acknowledged there is one evil attending this mode; that if the portrait were seen previous to any knowledge of the original, different persons would form different ideas, and all would be disappointed at not finding the original correspond with their own conceptions; under the great latitude which indistinctness gives to

the imagination to assume almost what character or form it pleases.

Every artist has some favourite part on which he fixes his attention, and which he pursues with such eagerness, that it absorbs every other consideration; and he often falls into the opposite error of that which he would avoid, which is always ready to receive him. Now Gainsborough, having truly a painter's eye for colouring, cultivated those effects of the art which proceed from colours: and sometimes appears to be indifferent to or to neglect other excellencies. Whatever defects are acknowledged, let him still experience from us the same candour that we so freely give upon similar occasions to the ancient masters; let us not encourage that fastidious disposition, which is discontented with everything short of perfection, and unreasonably require, as we sometimes do, a union of excellencies, not perhaps quite compatible with each other. We may, on this ground, say even of the divine Raphael, that he might have finished his picture as highly and as correctly, as was his custom, without heaviness of manner; and that Poussin might have preserved all his precision without hardness or dryness.

To show the difficulty of uniting solidity with lightness of manner, we may produce a picture of Rubens

in the church of St. Gudule, at Brussels, as an example; the subject is *Christ's Charge to Peter*; which, as it is the highest and smoothest finished picture I remember to have seen of that master, so it is by far the heaviest; and if I had found it in any other place, I should have suspected it to be a copy; for painters know very well, that it is principally by this air of facility, or the want of it, that originals are distinguished from copies.[1] A lightness of effect produced by colour, and that produced by facility of handling, are generally united; a copy may preserve something of the one, it is true, but hardly ever of the other; a connoisseur, therefore, finds it often necessary to look carefully into the picture before he determines on its originality. Gainsborough possessed this quality of lightness of manner and effect, I think, to an unexampled degree of excellence; but it must be acknowledged, at the same time, that the sacrifice which he made to this ornament of our art was too great; it was, in reality, preferring the lesser excellencies to the greater.

To conclude. However we may apologise for the deficiencies of Gainsborough (I mean particularly his want of precision and finishing), who so ingeniously contrived to cover his defects by his beauties; and who

1. *c*. 1616, Wallace Collection, London

cultivated that department of art, where such defects are more easily excused; you are to remember, that no apology can be made for this deficiency, in that style which this Academy teaches, and which ought to be the object of your pursuit. It will be necessary for you, in the first place, never to lose sight of the great rules and principles of the art, as they are collected from the full body of the best general practice, and the most constant and uniform experience; this must be the groundwork of all your studies: afterwards you may profit, as in this case I wish you to profit, by the peculiar experience and personal talents of artists, living and dead; you may derive lights, and catch hints, from their practice; but the moment you turn them into models, you fall infinitely below them; you may be corrupted by excellencies, not so much belonging to the art, as personal and appropriated to the artist; and become bad copies of good painters, instead of excellent imitators of the great universal truth of things.

List of illustrations

All works by Gainsborough and oil on canvas unless noted

Photographs on pp. 8, 10-11, 19, 22-23, 30, 38, 43, 44, 46, 56-57, 61, 70, 86, 89, 90, 97, 99, 104, 118-19 and 135 courtesy Wikimedia Commons; on pp. 34-35, 62 and 110 courtesy the collectors and Anthony Mould; other photographs courtesy holding institutions

© 2018, 2021 Pallas Athene (Publishers) Ltd.

Published in the United States of America in 2021 by the J. Paul Getty Museum, Los Angeles
Getty Publications
1200 Getty Center Drive, Suite 500
Los Angeles, California 90049-1682
getty.edu/publications

Distributed in the United States and Canada by the University of Chicago Press

Printed in China

ISBN 978-1-60606-664-5
Library of Congress Control Number: 2020937438

Published in the United Kingdom by Pallas Athene (Publishers) Ltd.
2 Birch Close, London N19 5XD

Alexander Fyjis-Walker, *Series Editor*
Anaïs Métais, Patrick Davies and Joshua Hunter, *Editorial Assistants*

Front cover: Attributed to Thomas Gainsborough (1727–1788) and reworked by Gainsborough
Dupont (1754–1797), *Portrait of Thomas Gainsborough*, 1774–88. Oil on canvas, 76.6 x 63.5 cm
(30³⁄₁₆ x 25 in.). The Courtauld Gallery, Gift of Samuel Courtauld, 1932, P.1932.SC.100. The
Courtauld Gallery, London, UK / Bridgeman Images

Note to the reader: Philip Thicknesse published *A Sketch of the Life and Paintings of Thomas Gainsborough, Esq.* in London in 1788. His idiosyncratic punctuation, capitalization, and emphasis have been retained, as well as his breathless lack of paragraphing. His spelling, however, has been modernized. William Jackson published *The Four Ages: Together with essays on various subjects* in Exeter in 1798. His spelling has been modernized. Sir Joshua Reynolds delivered a series of discourses to students at the Royal Academy between 1769 and 1790. *Discourse XIV* was the penultimate one of the series, and like the others was published shortly after its delivery. The spelling of painters' names has generally been modernized.